Arf! Arf! Studios
Canmer, KY

THE PALMER COX BROWNIES COLORING BOOK

published by Arf! Arf! Studios

Layout and design & new material by Jim Erskine

The design of this coloring book
and all new material is
Copyright 2016 by Arf! Arf! Studios, all rights reserved

These wonderful drawings have been scanned and cleaned up
from our very own original tattered and beloved 1890 copy of
Another Brownie Book by Palmer Cox.

When we were kids and we saw this Brownie book,
we always wanted to color the pictures, but we were told:
"You don't color in real books".
So all these years later, we finally
put our friends the Brownies into their very own
coloring book - for us and every other child-at-heart
to enjoy, color, relive fond memories, and make new ones.

Have fun, and remember...
the Brownies are watching you!

PS. Look for our other delightful coloring books
on Amazon. Just search for "Arf Arf Studios"

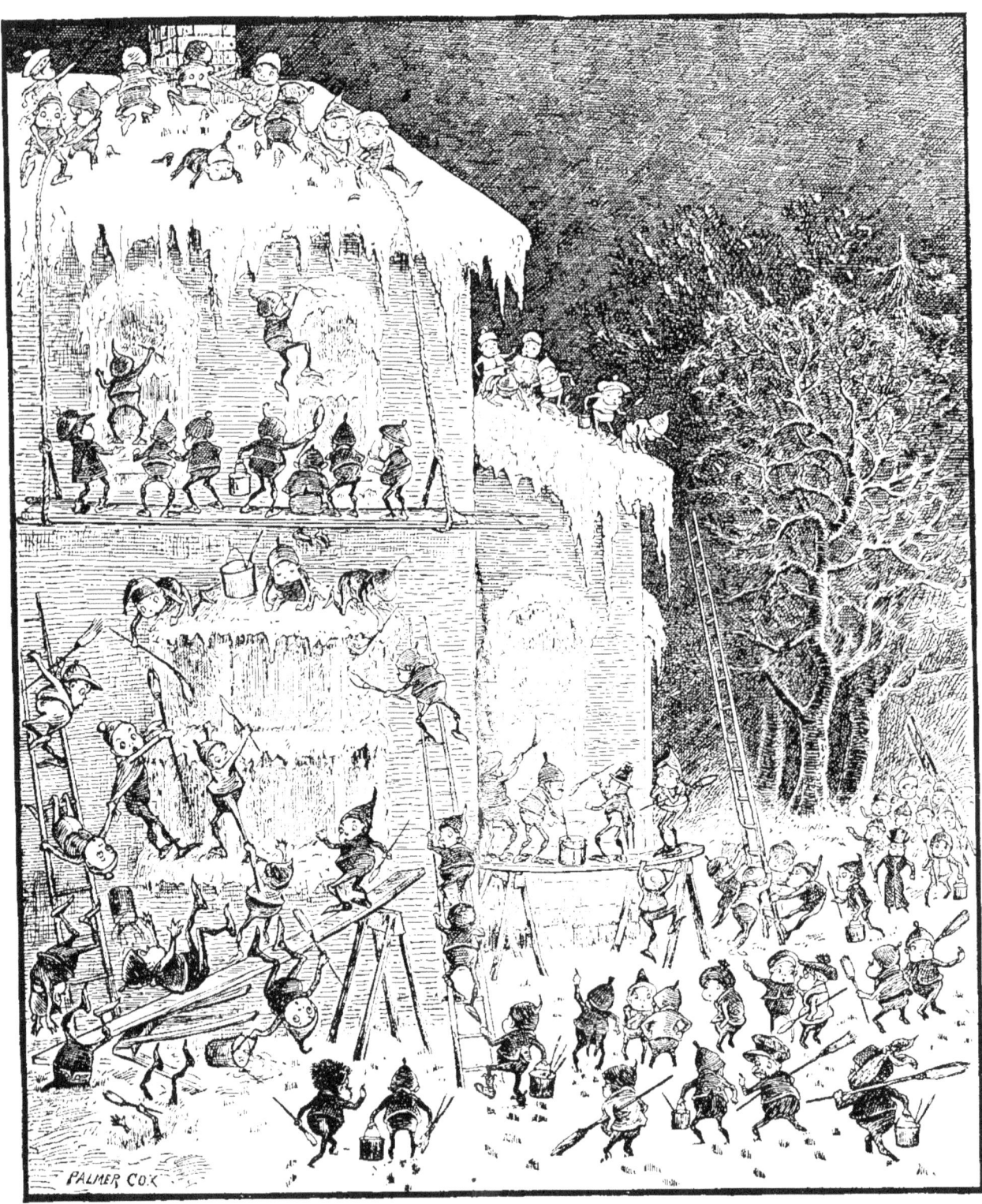

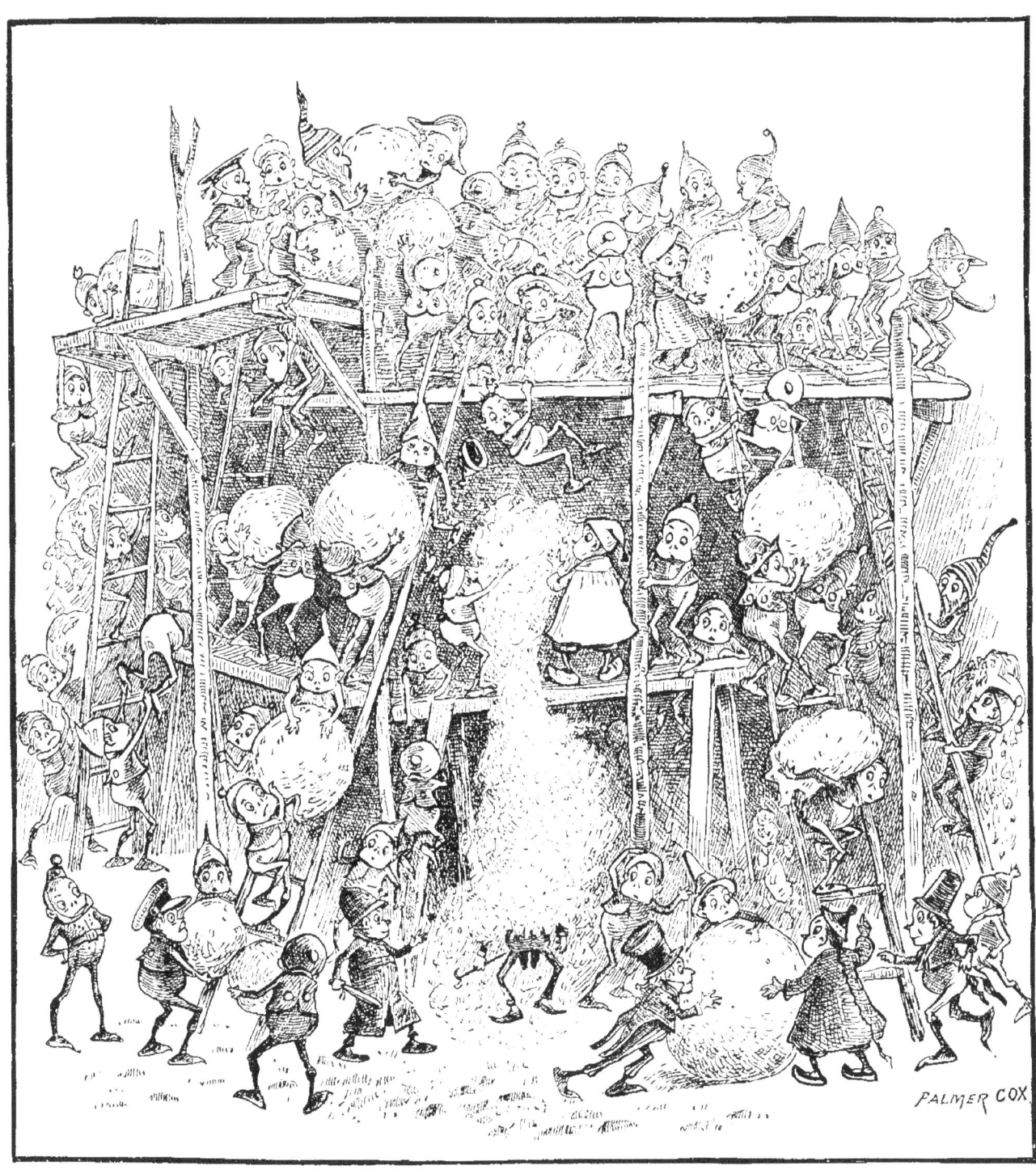

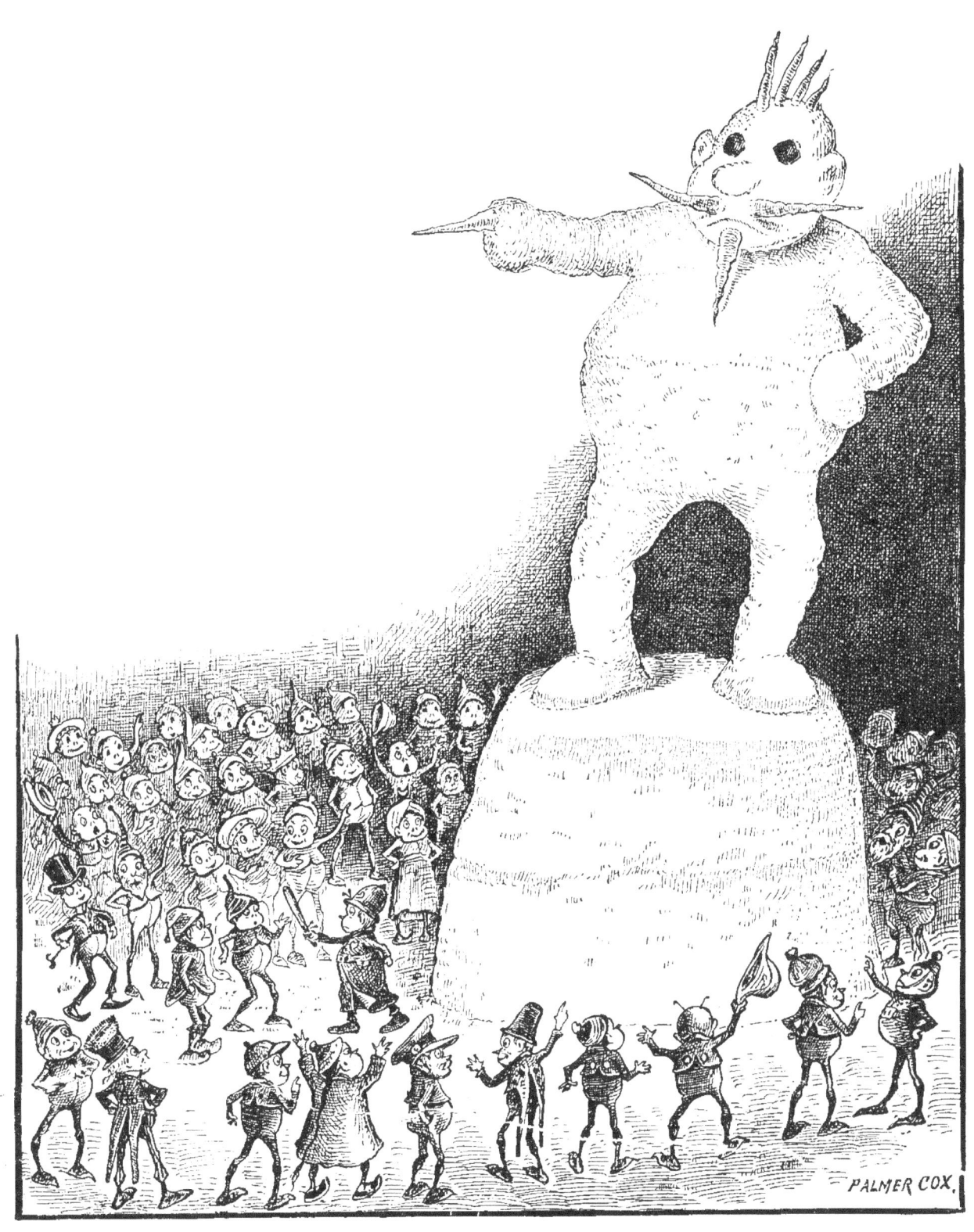

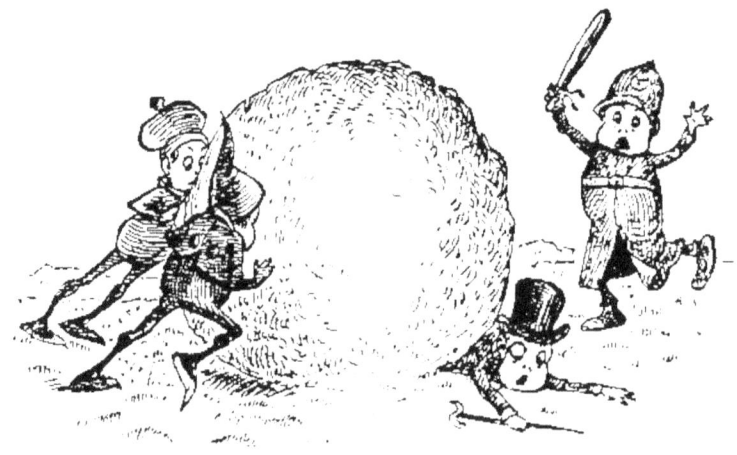

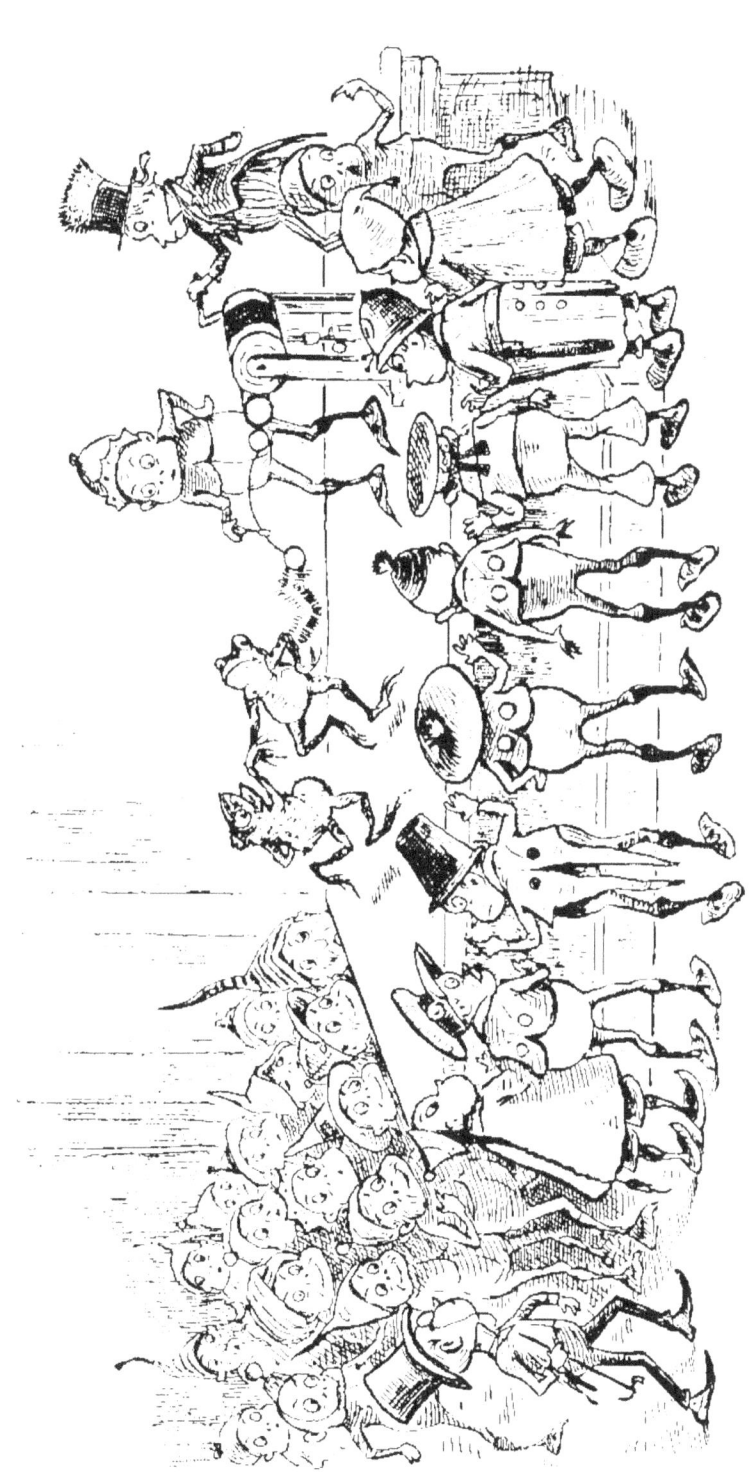

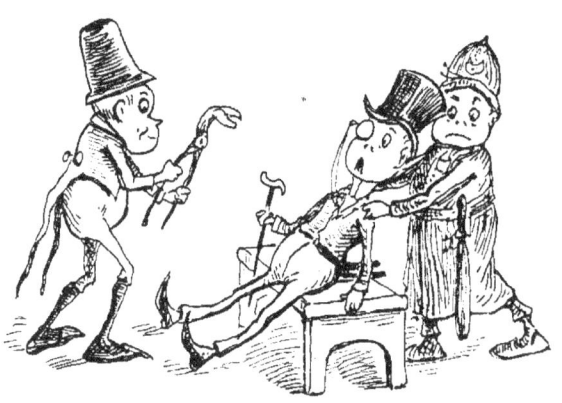
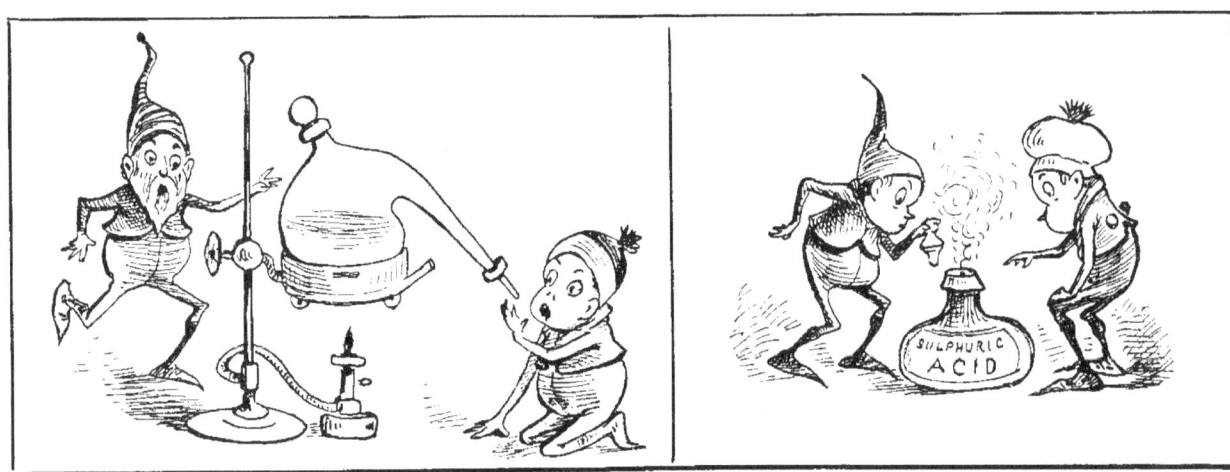

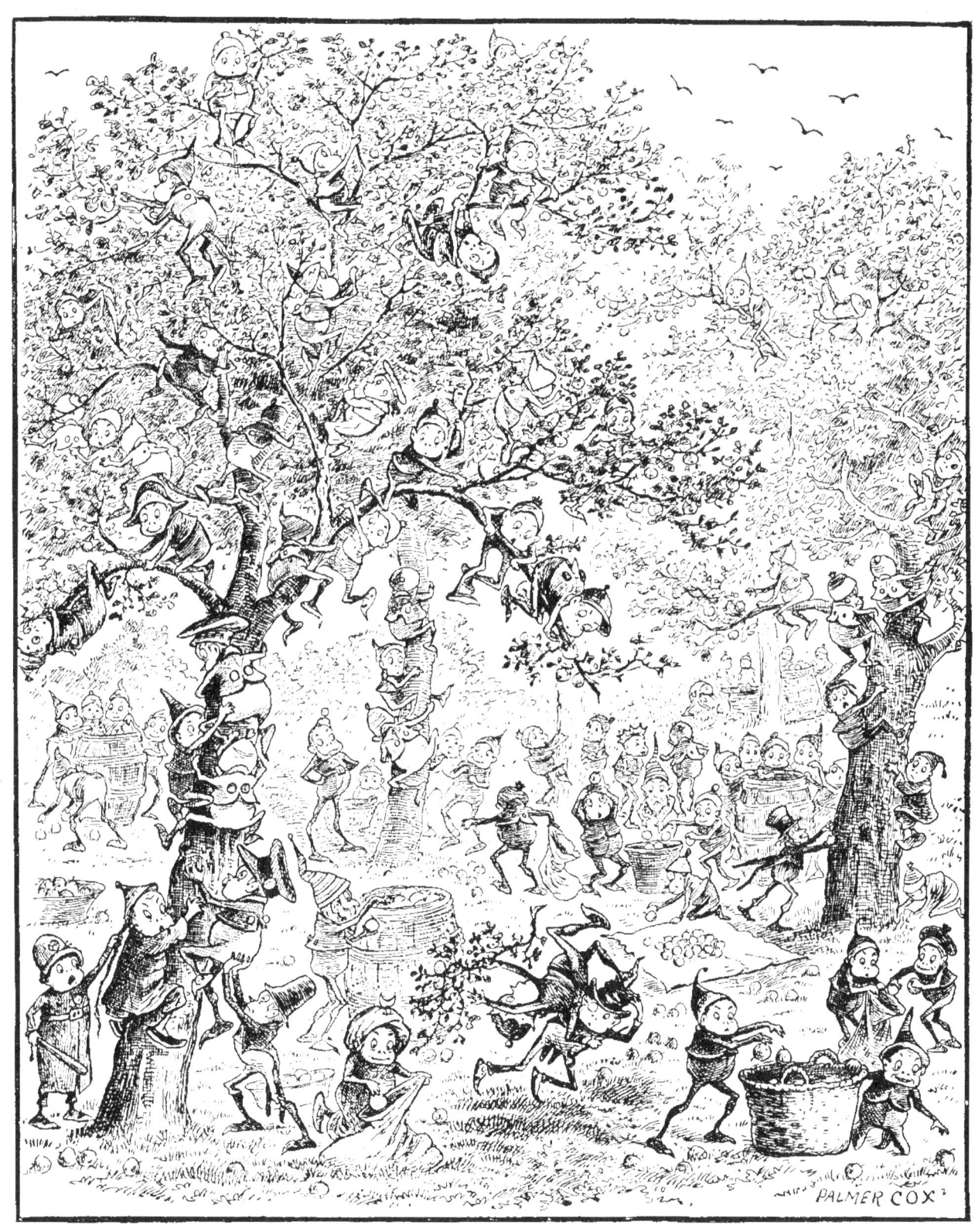

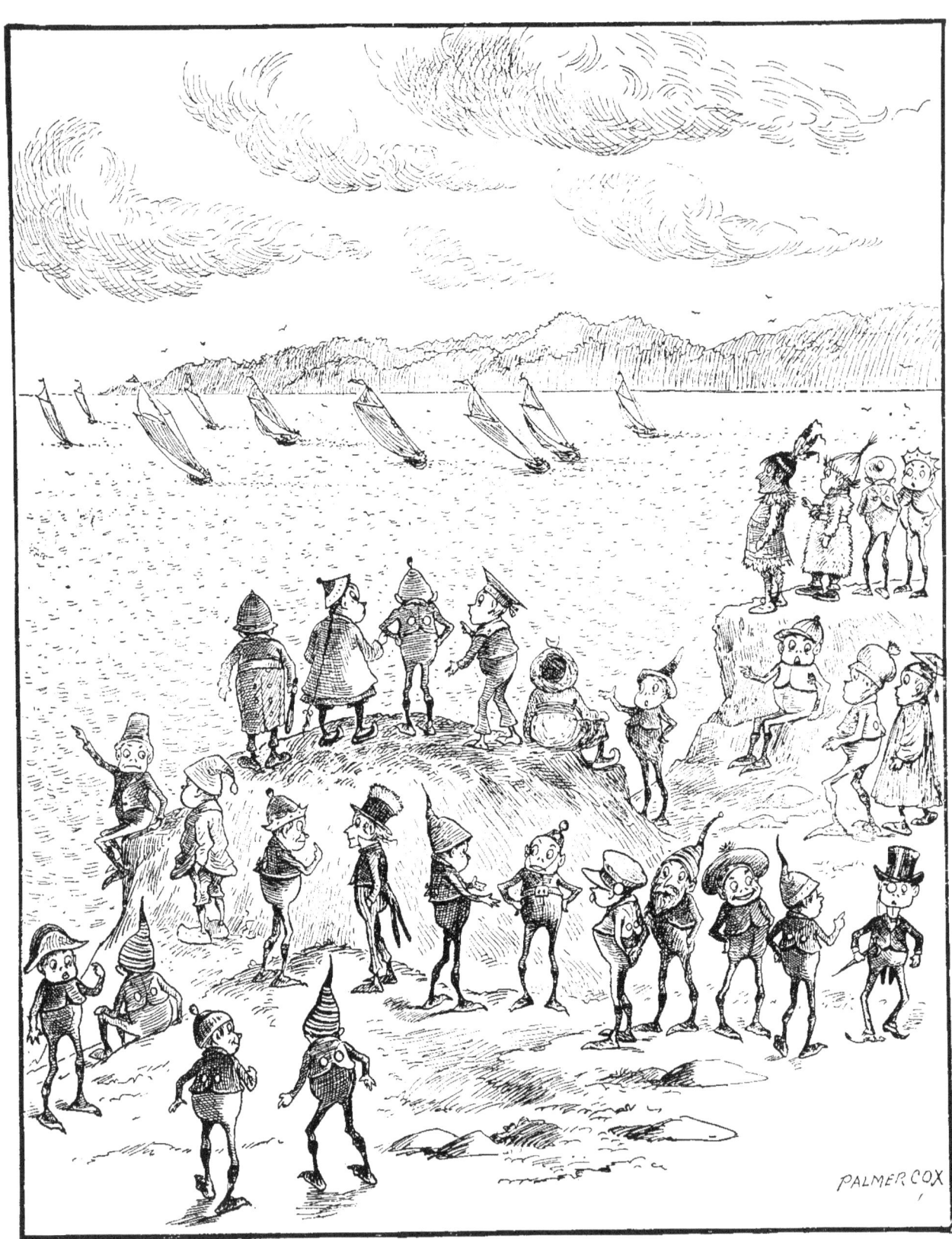

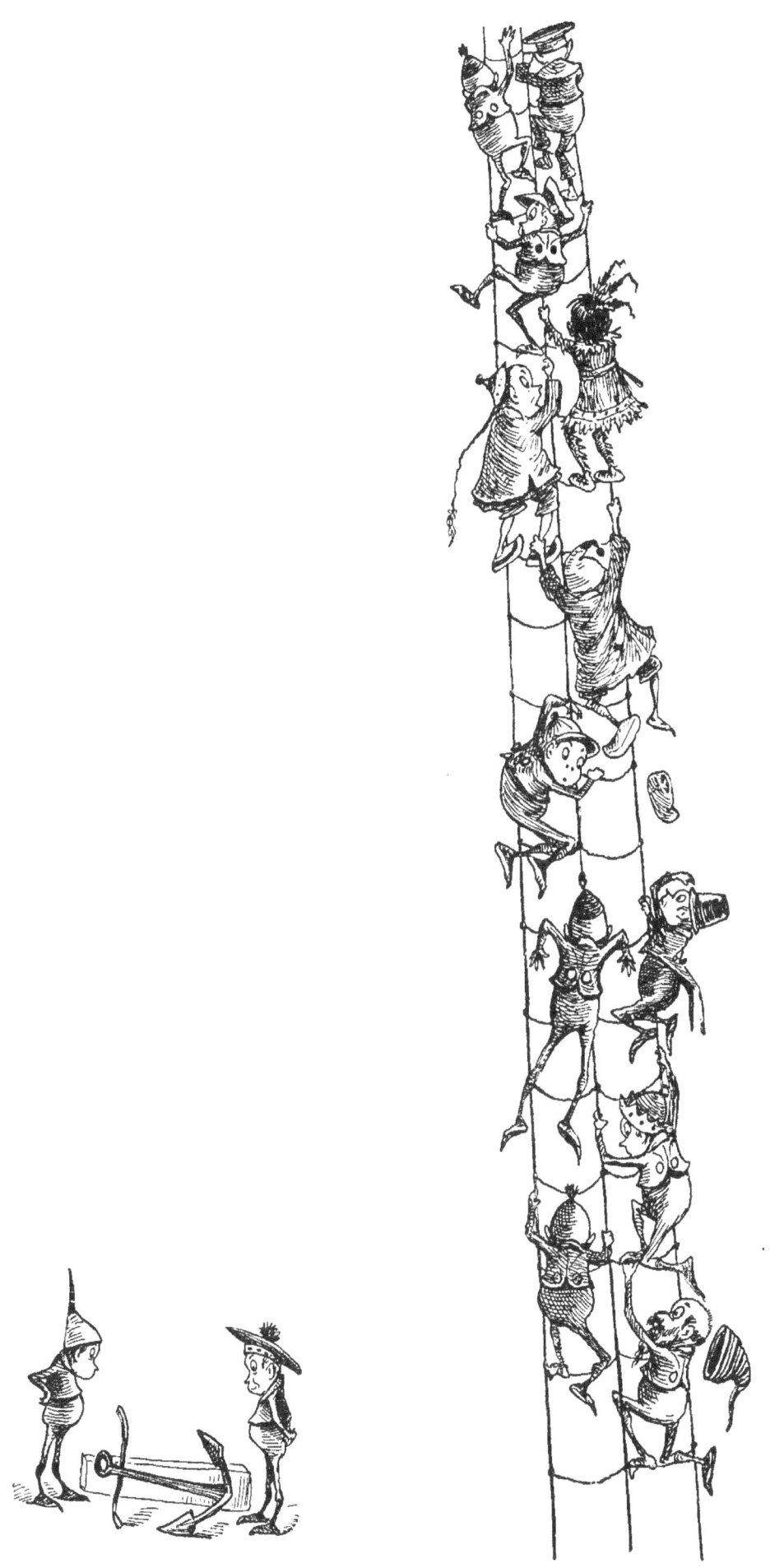

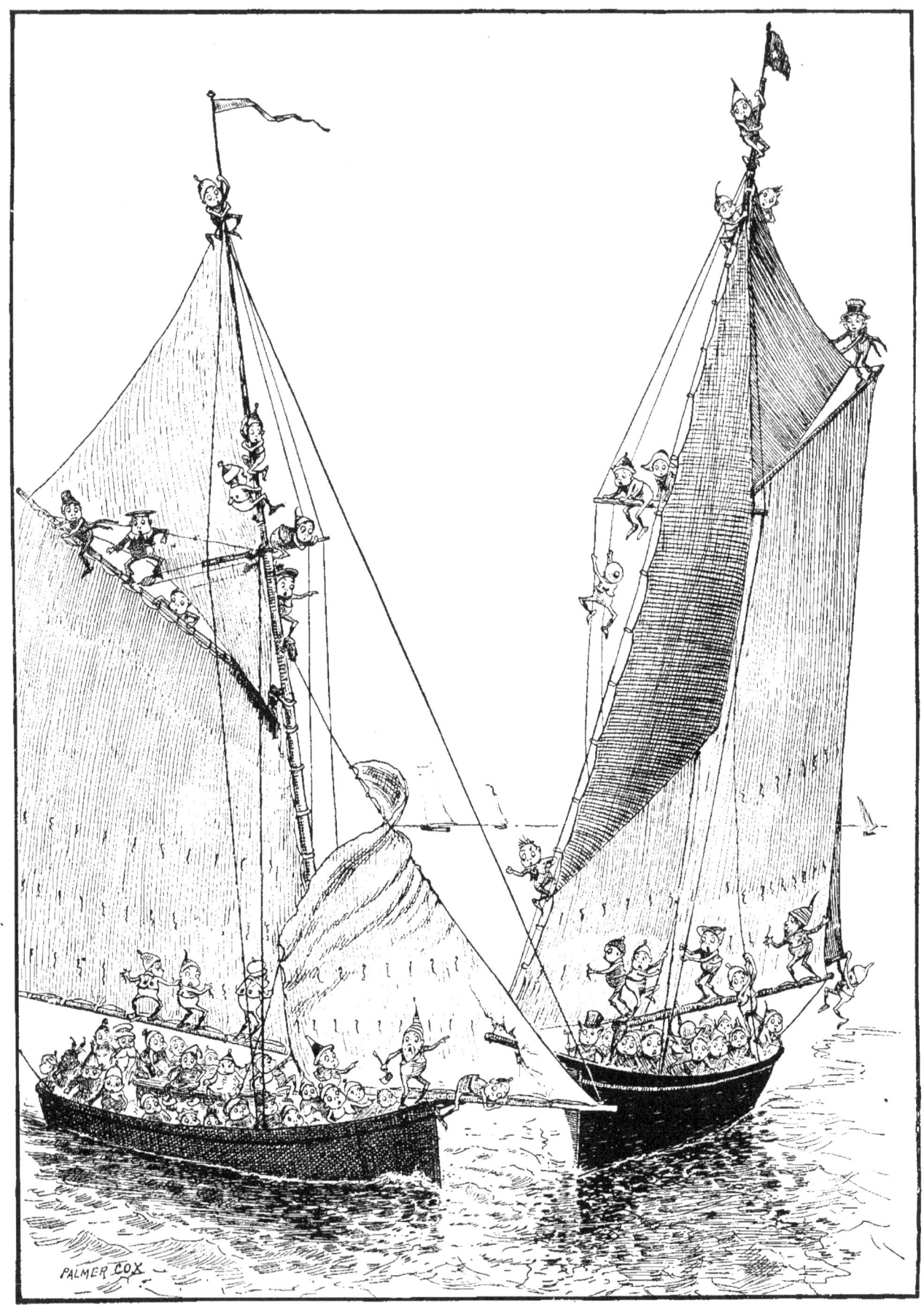

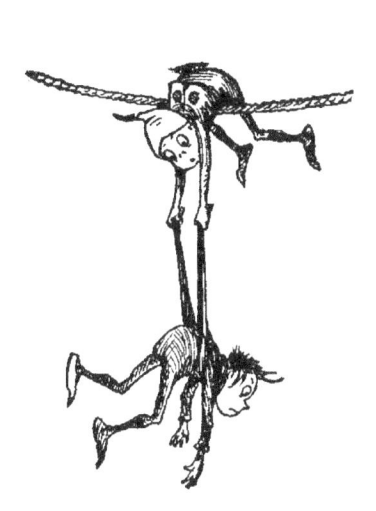
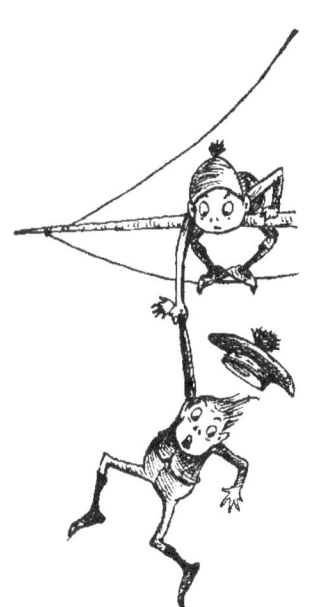

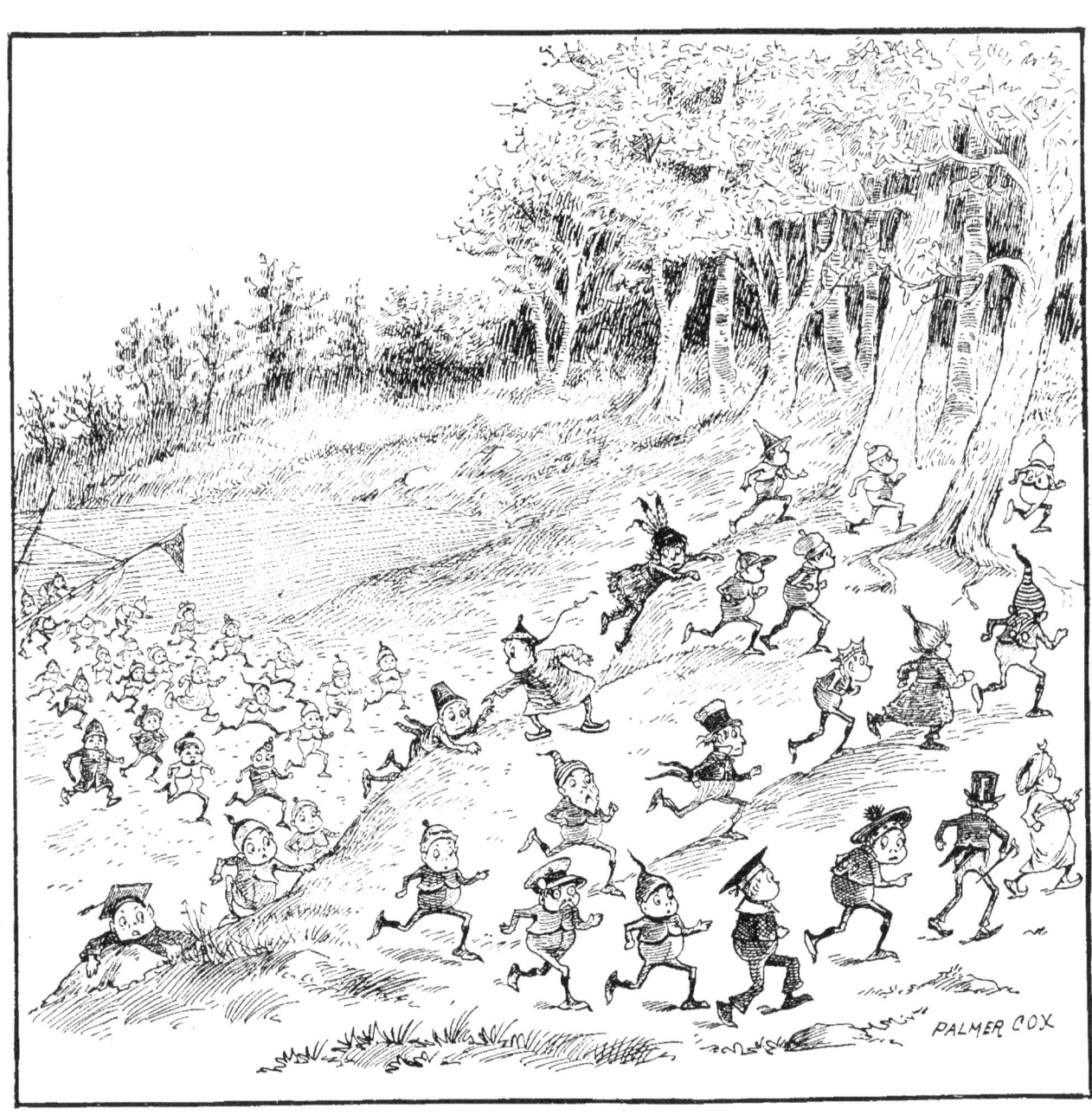

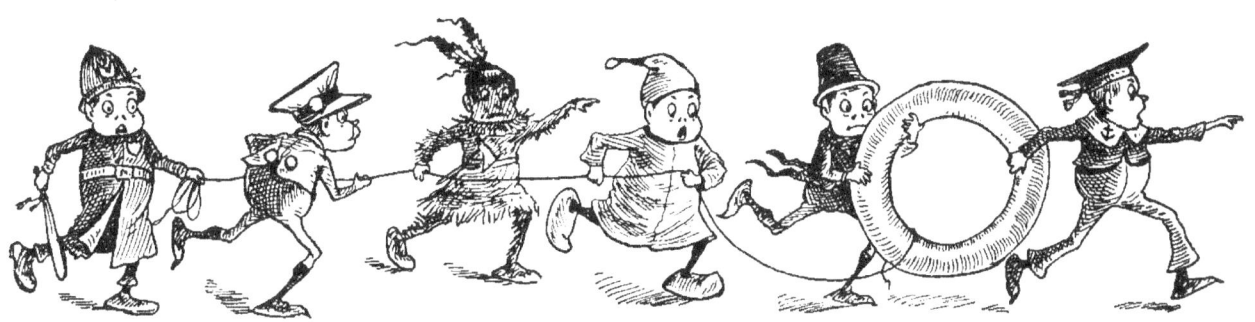

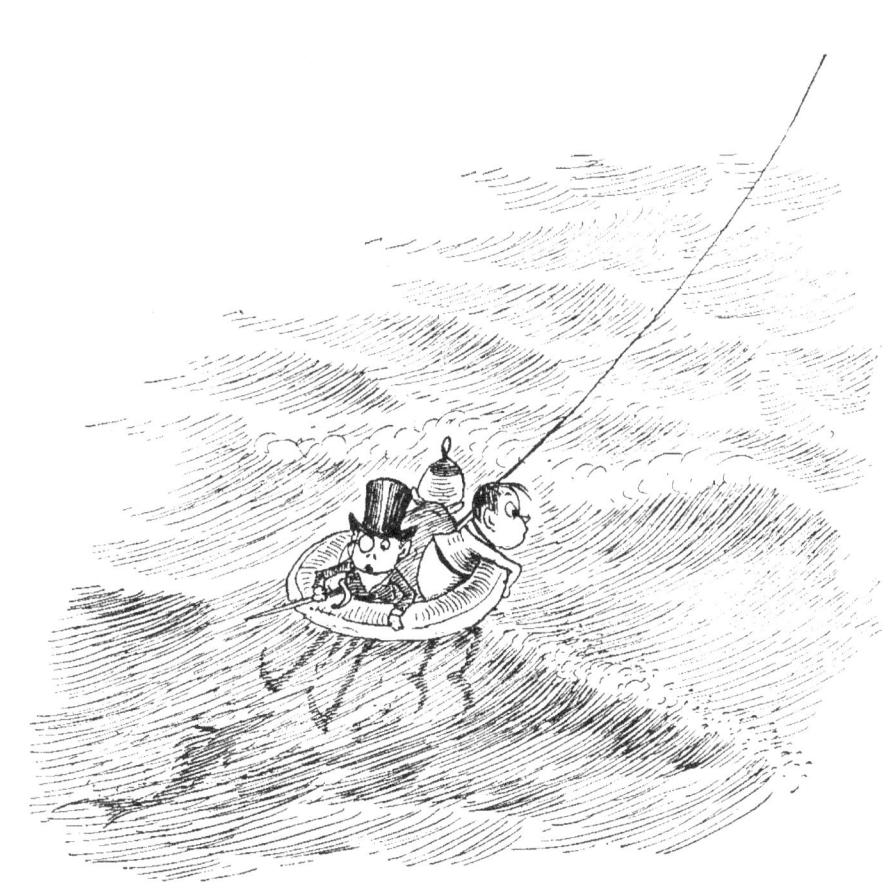

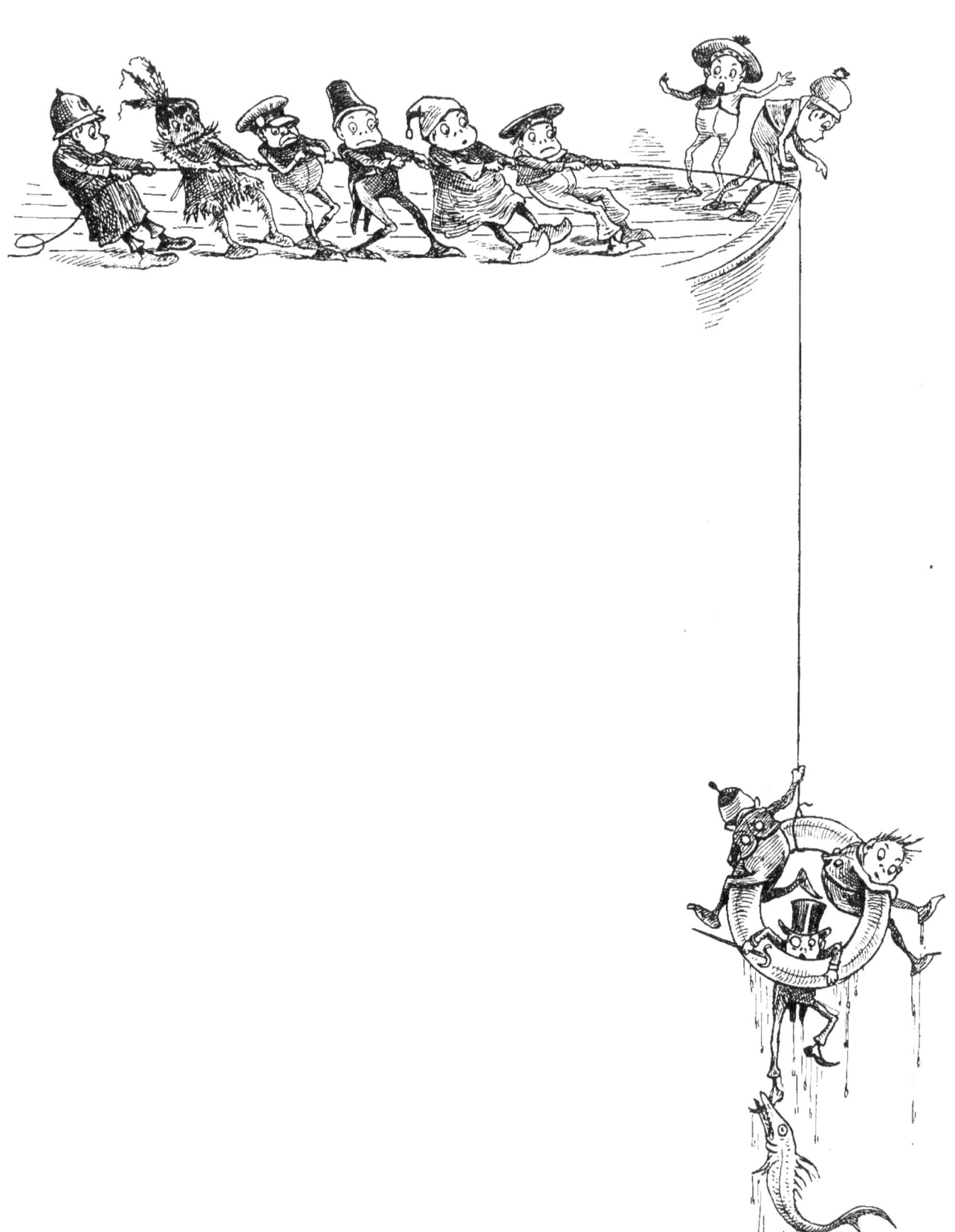

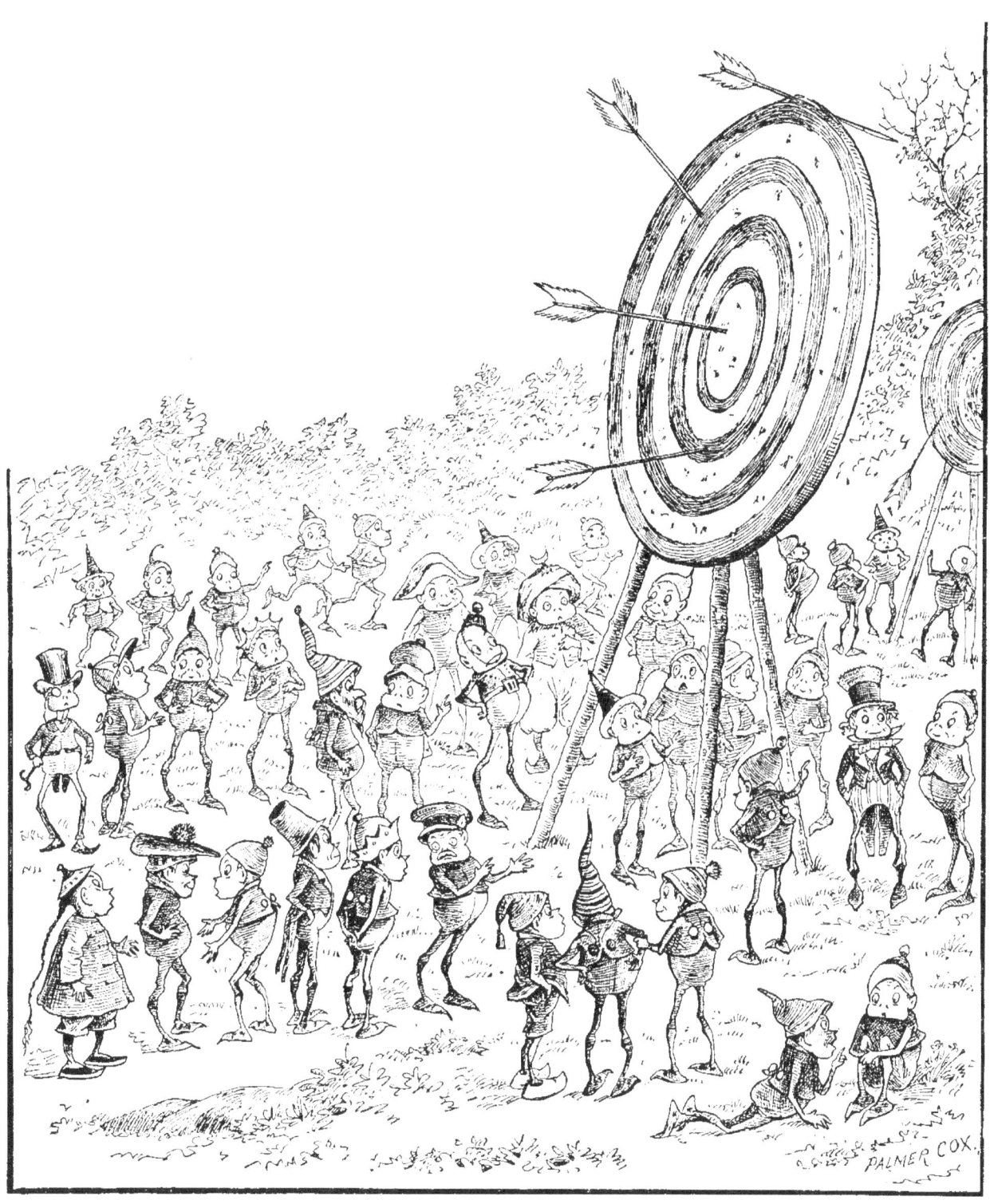

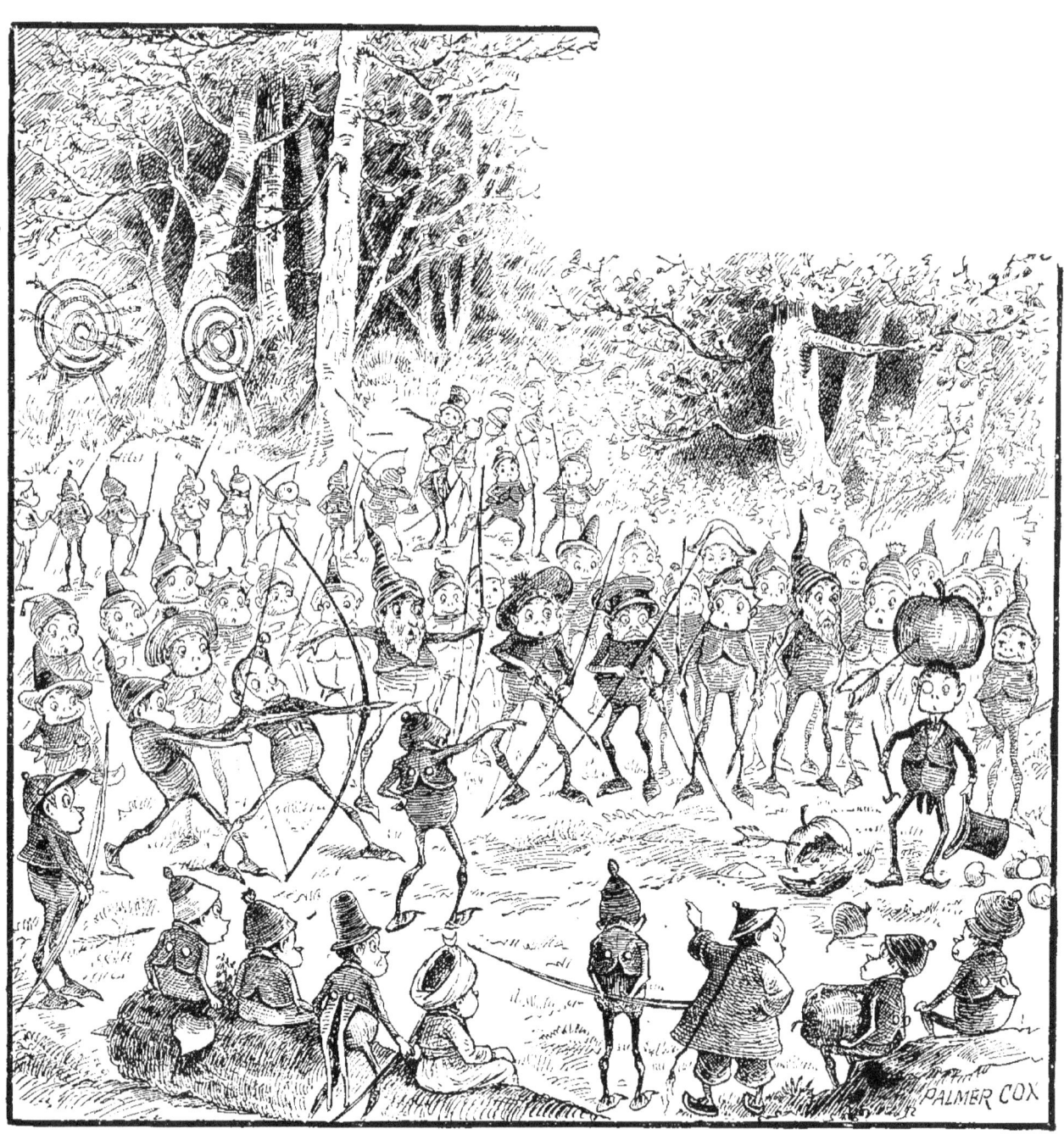

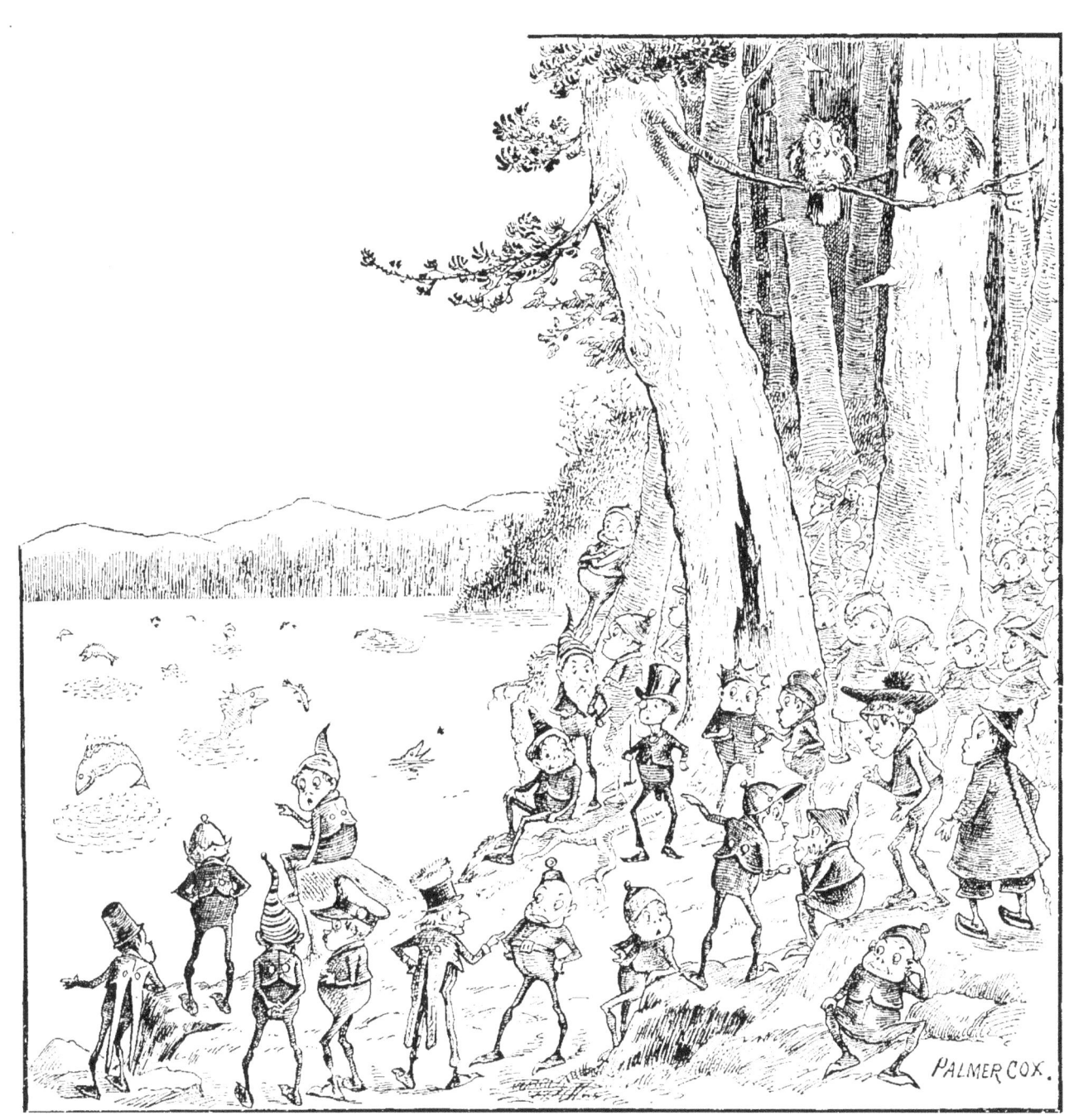

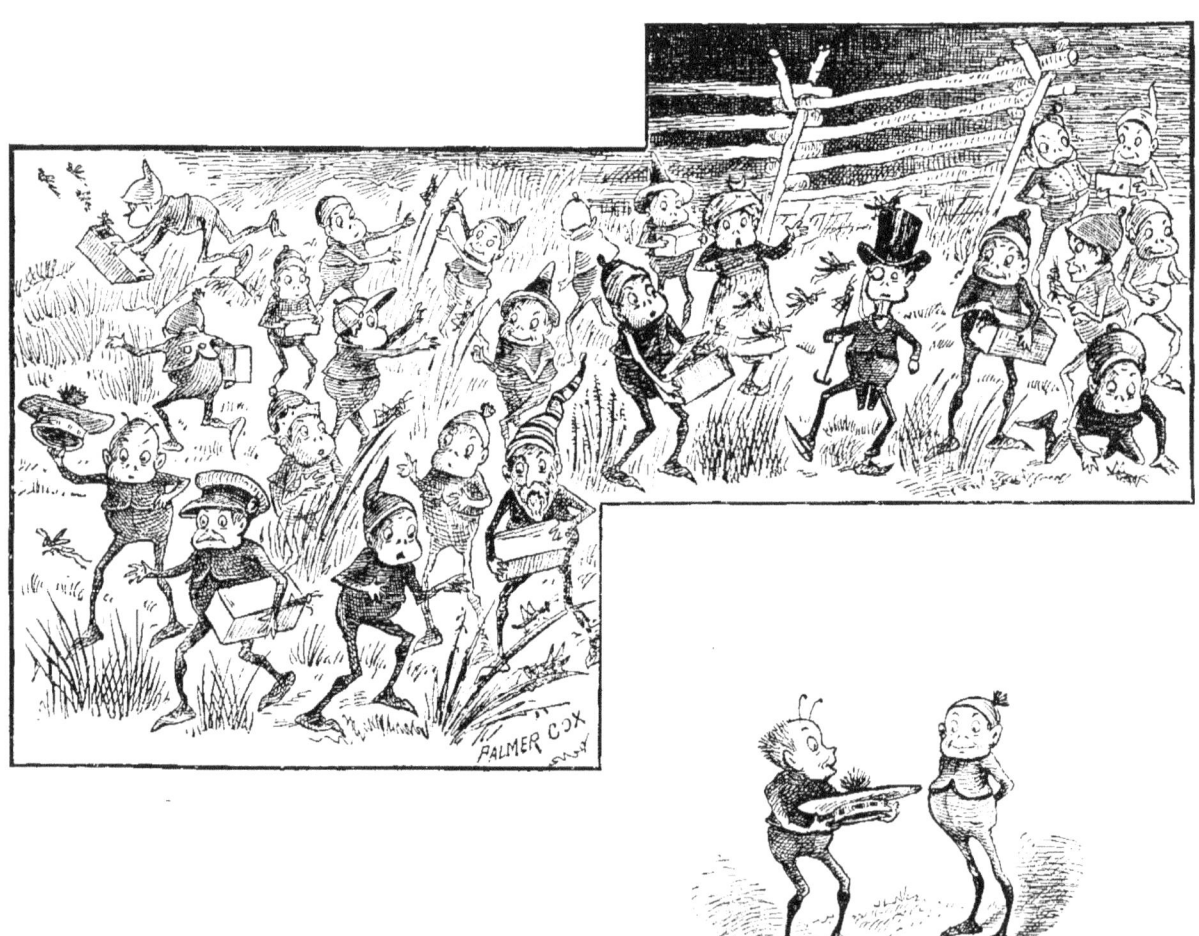

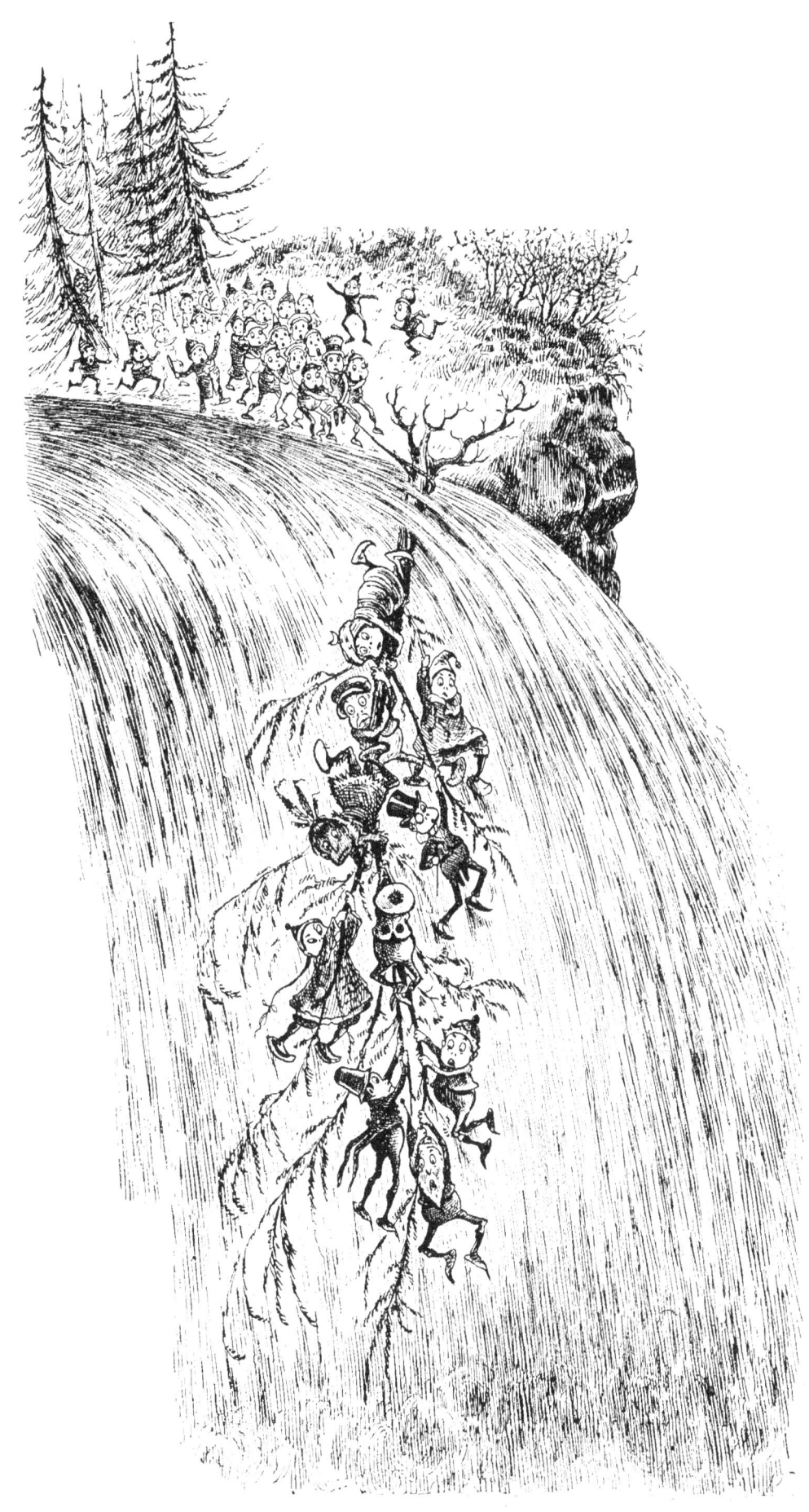

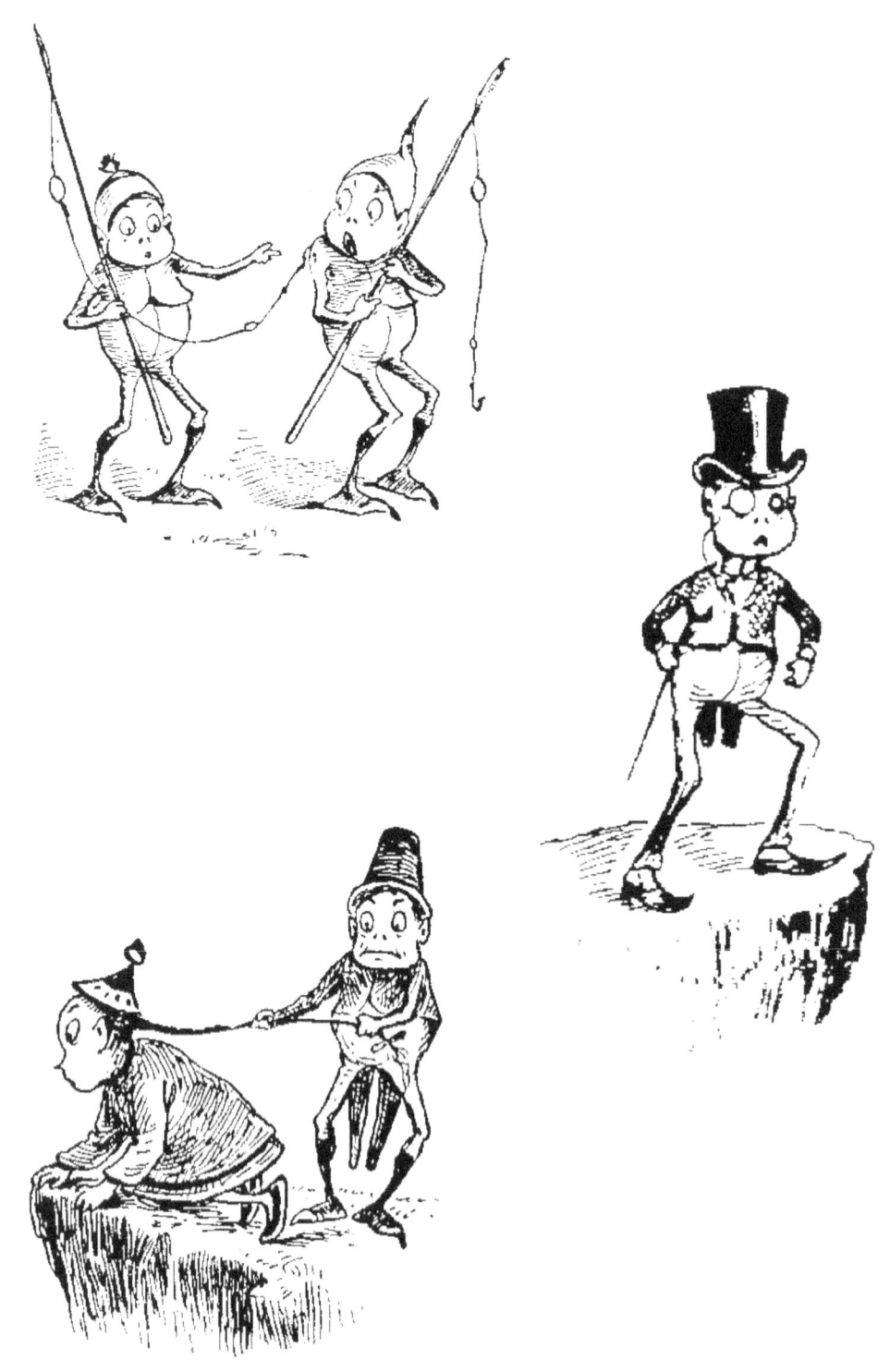

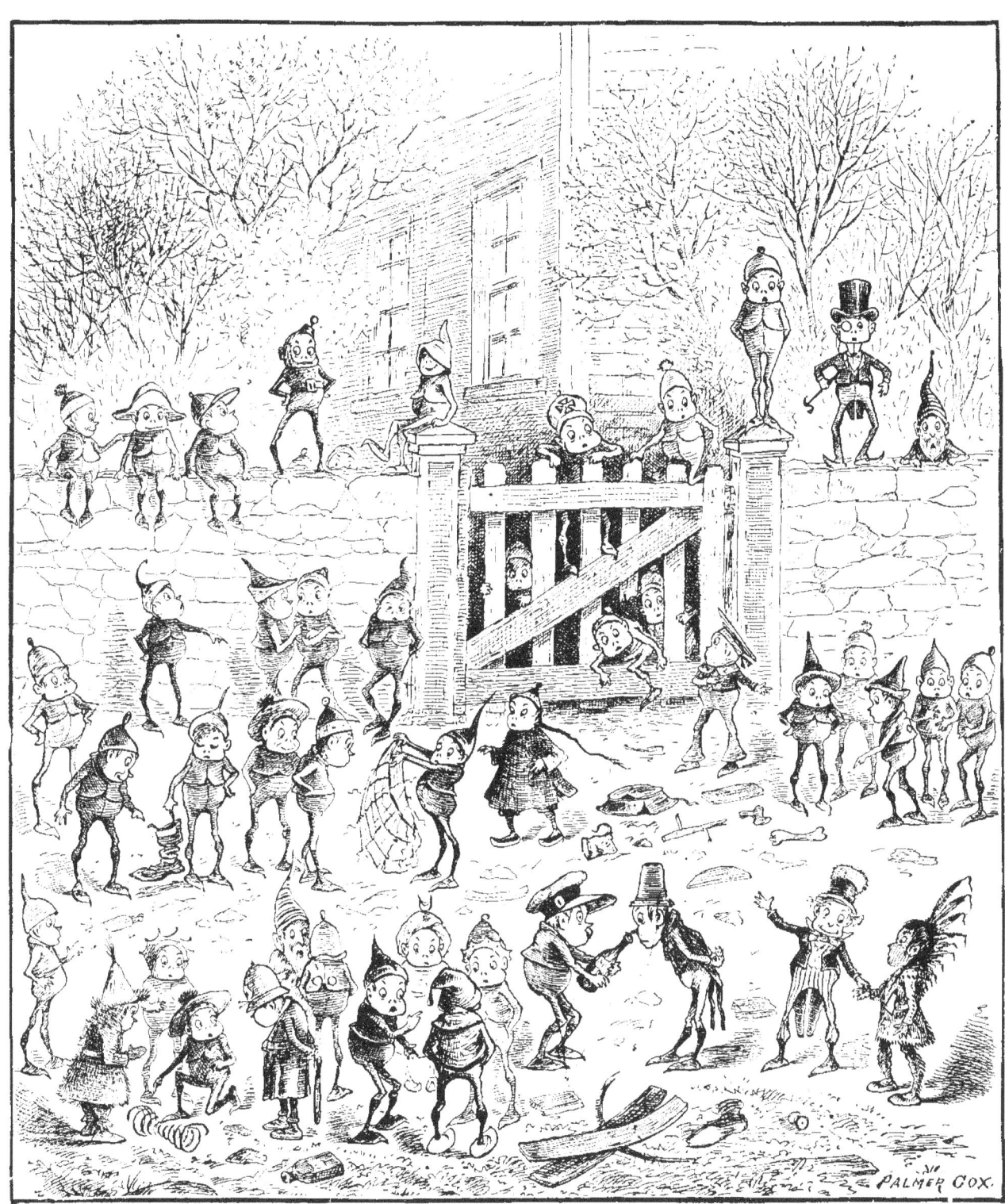

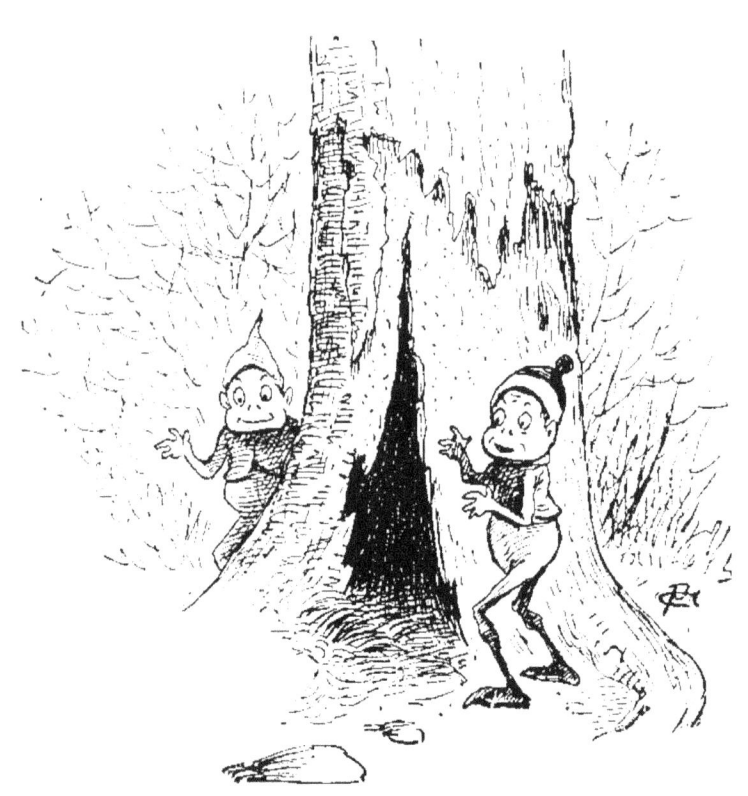

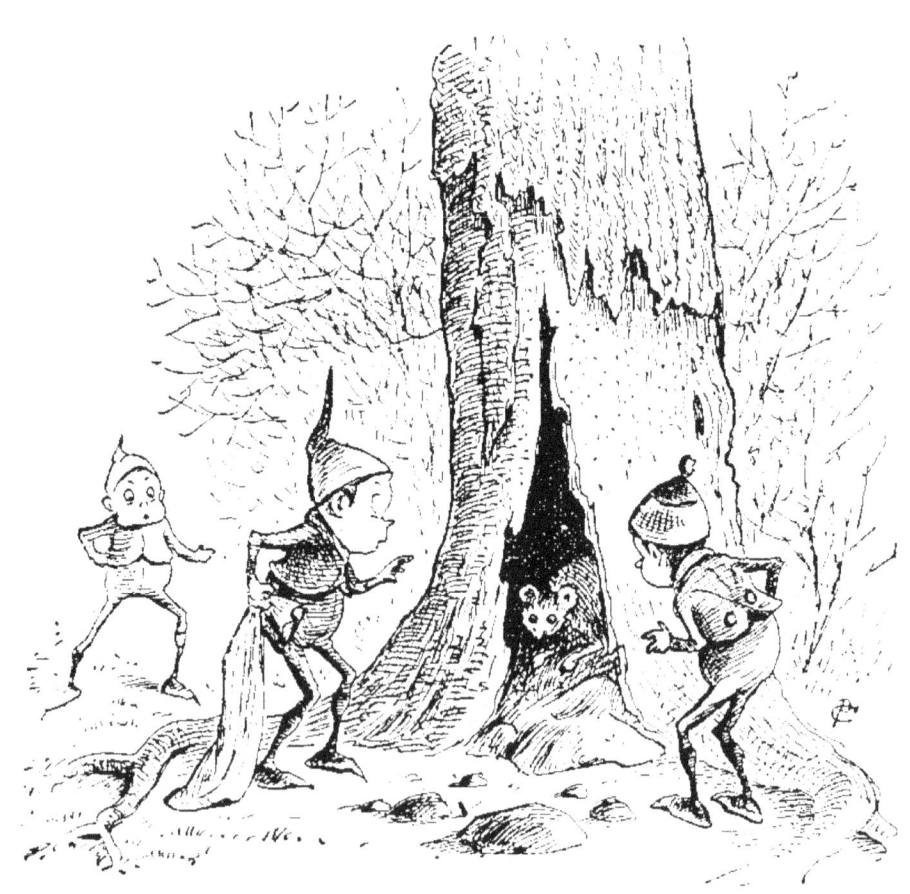

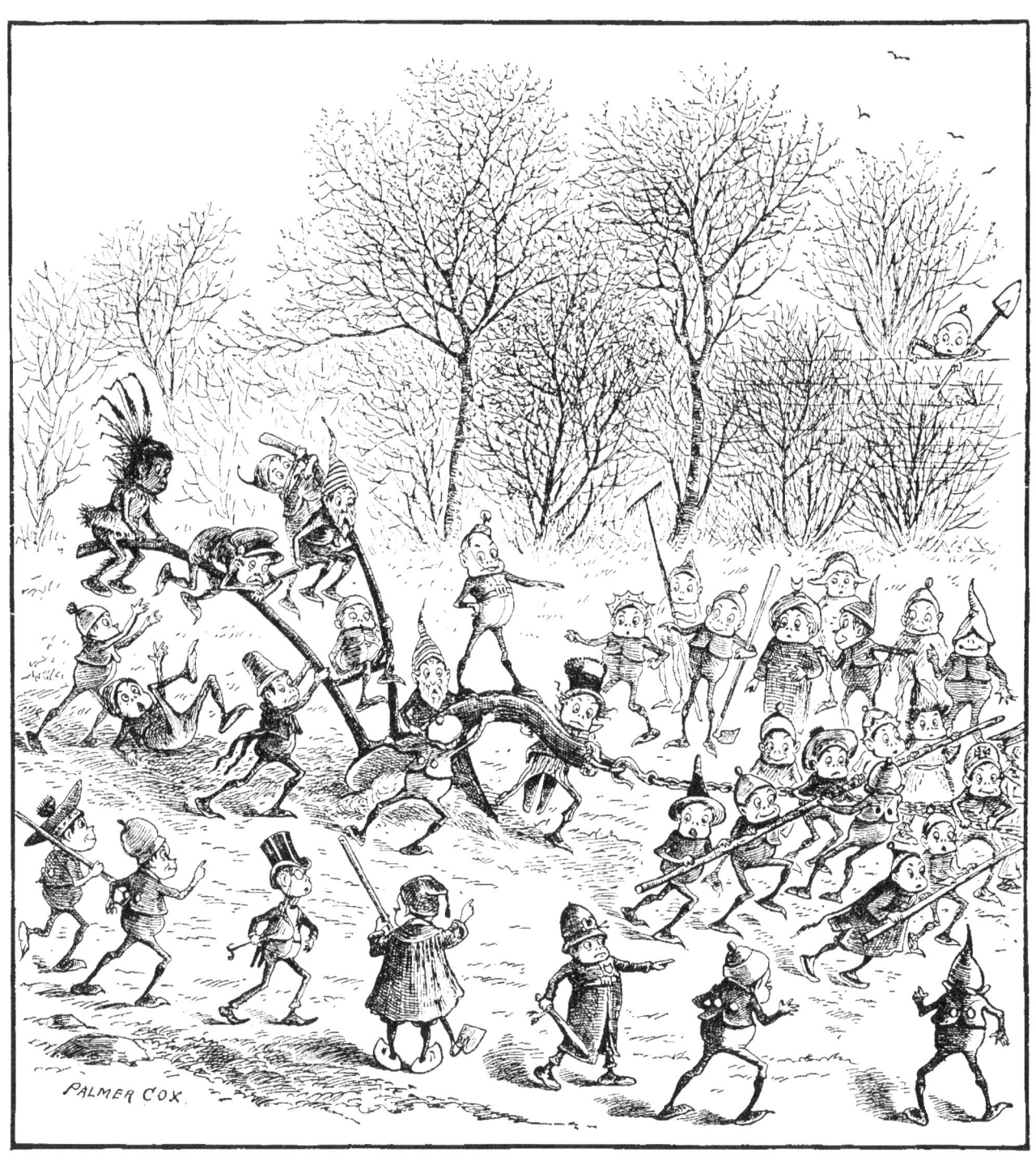

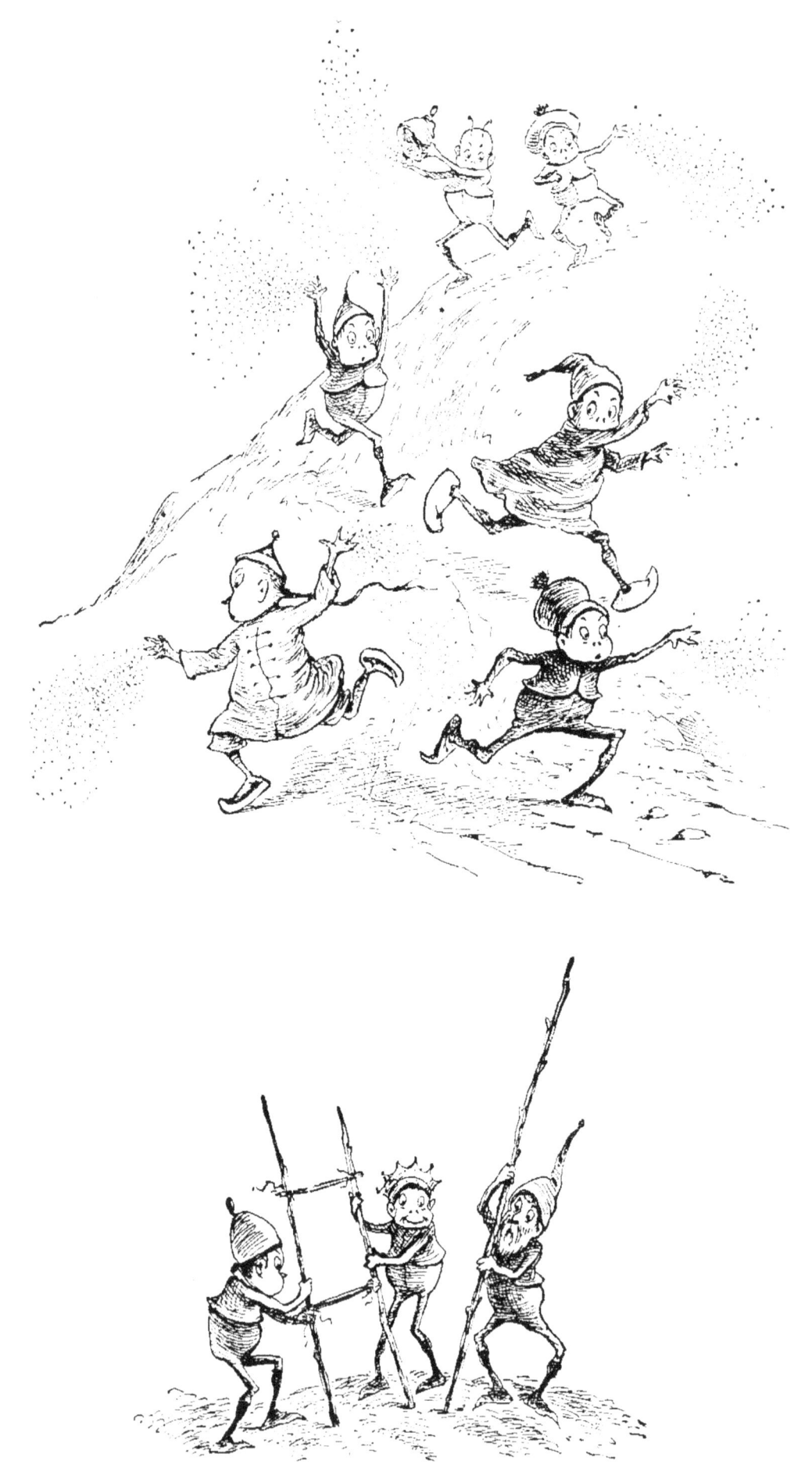

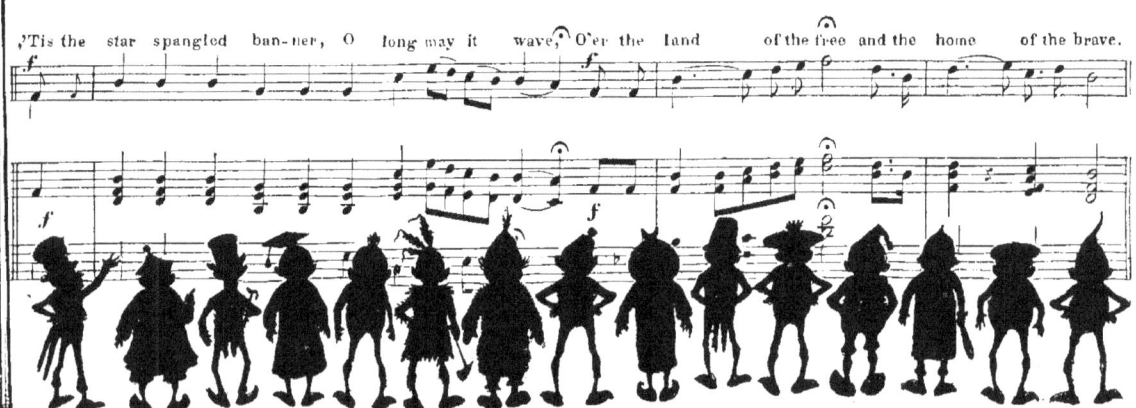

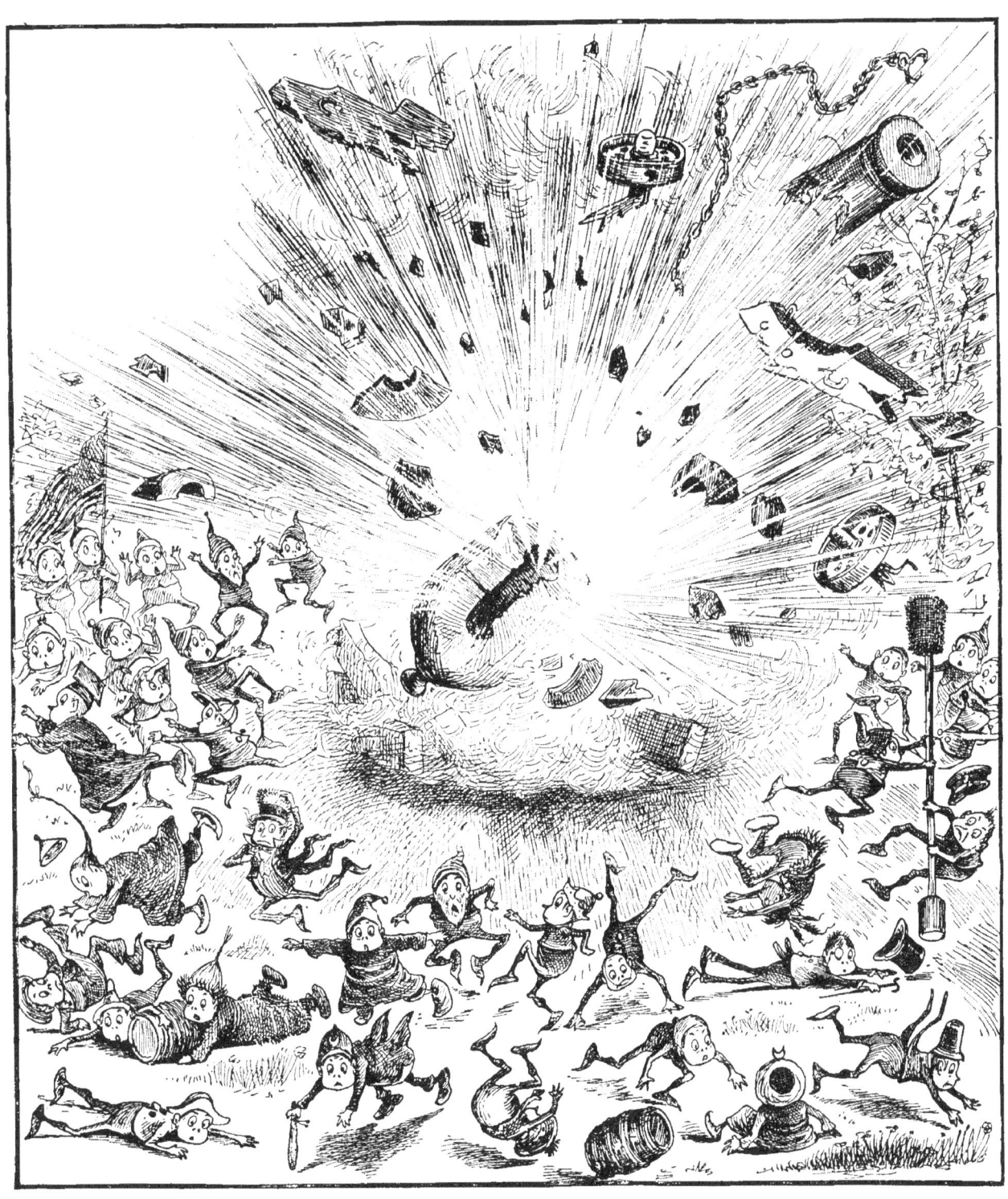

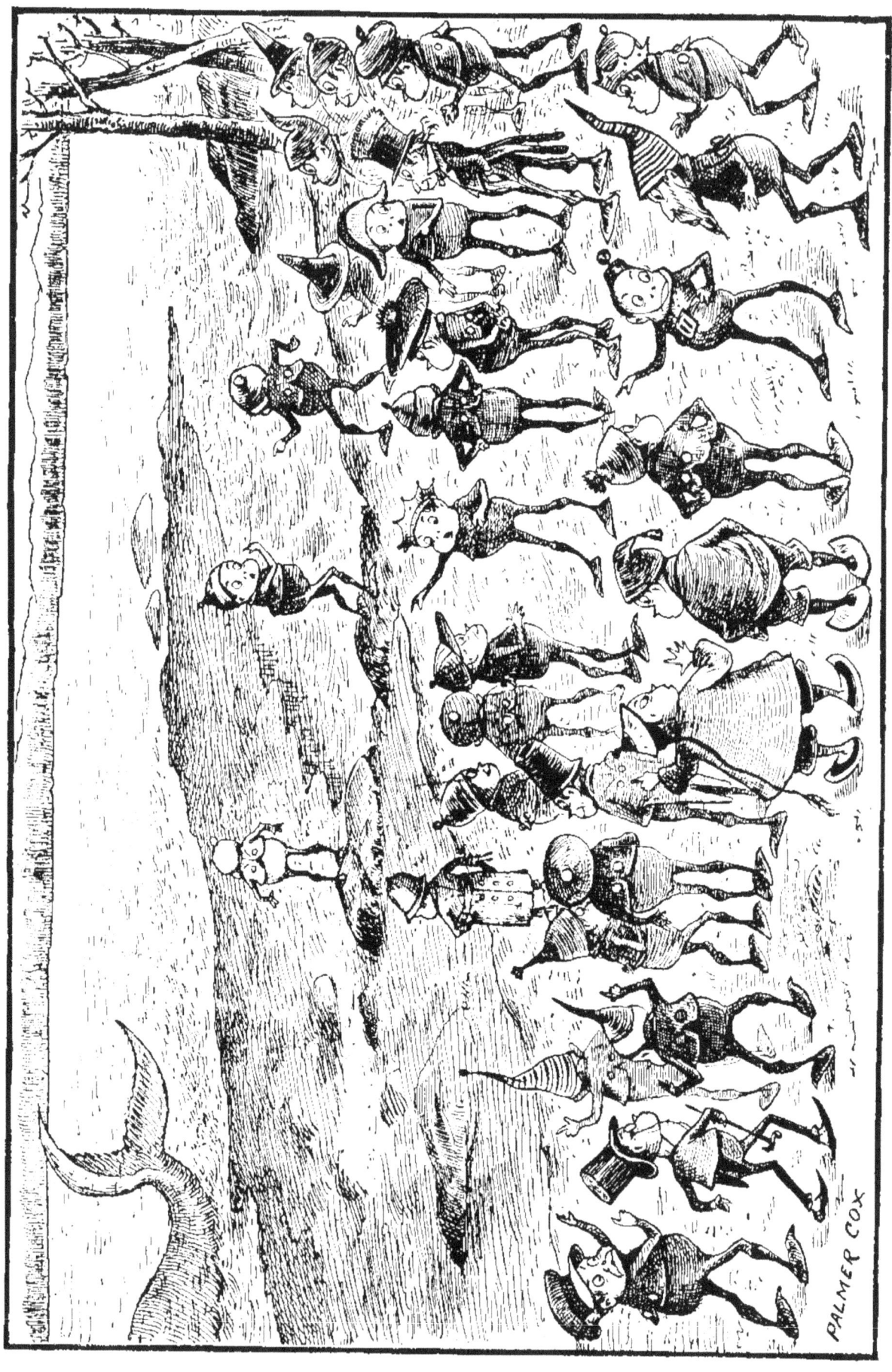

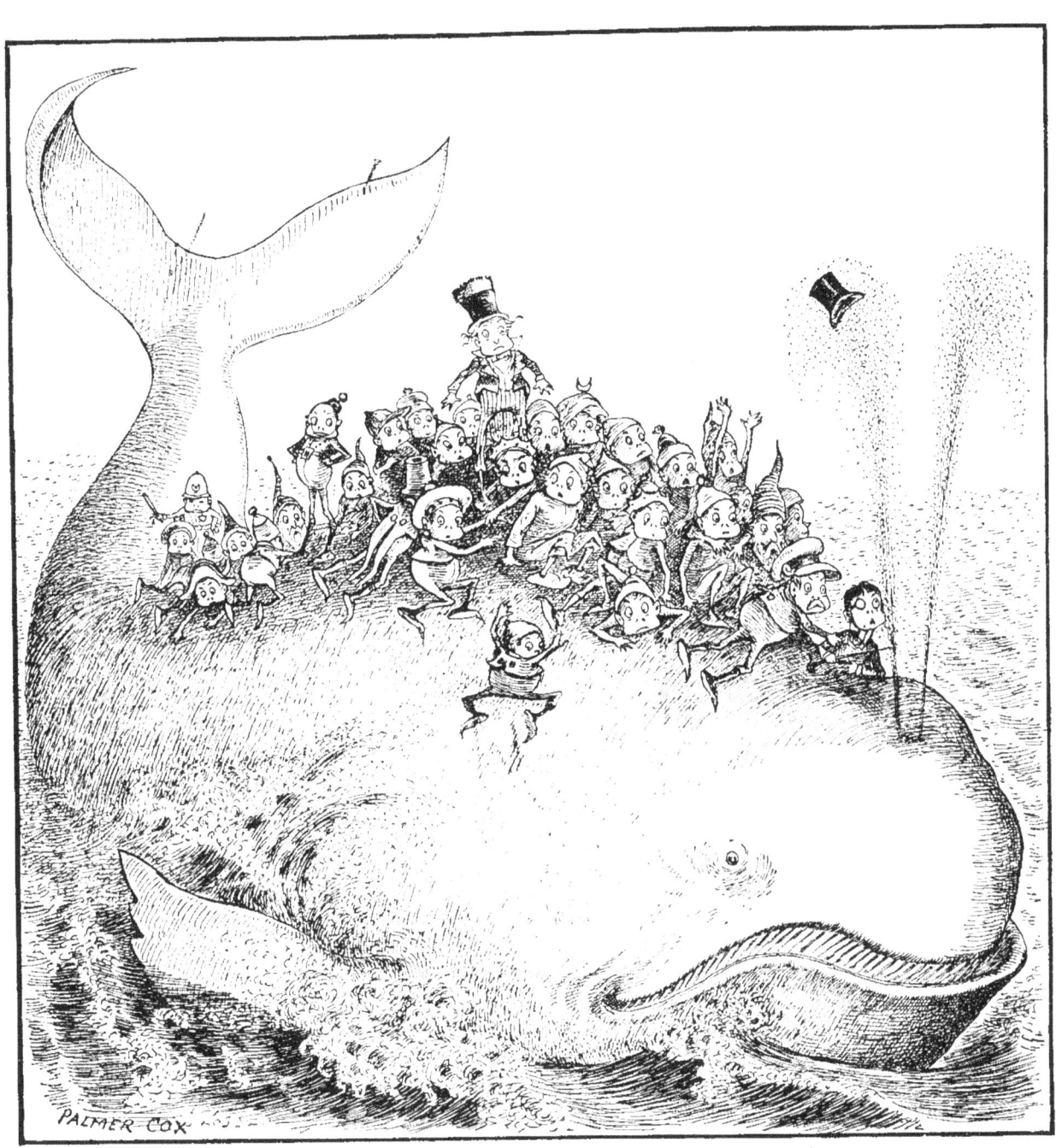

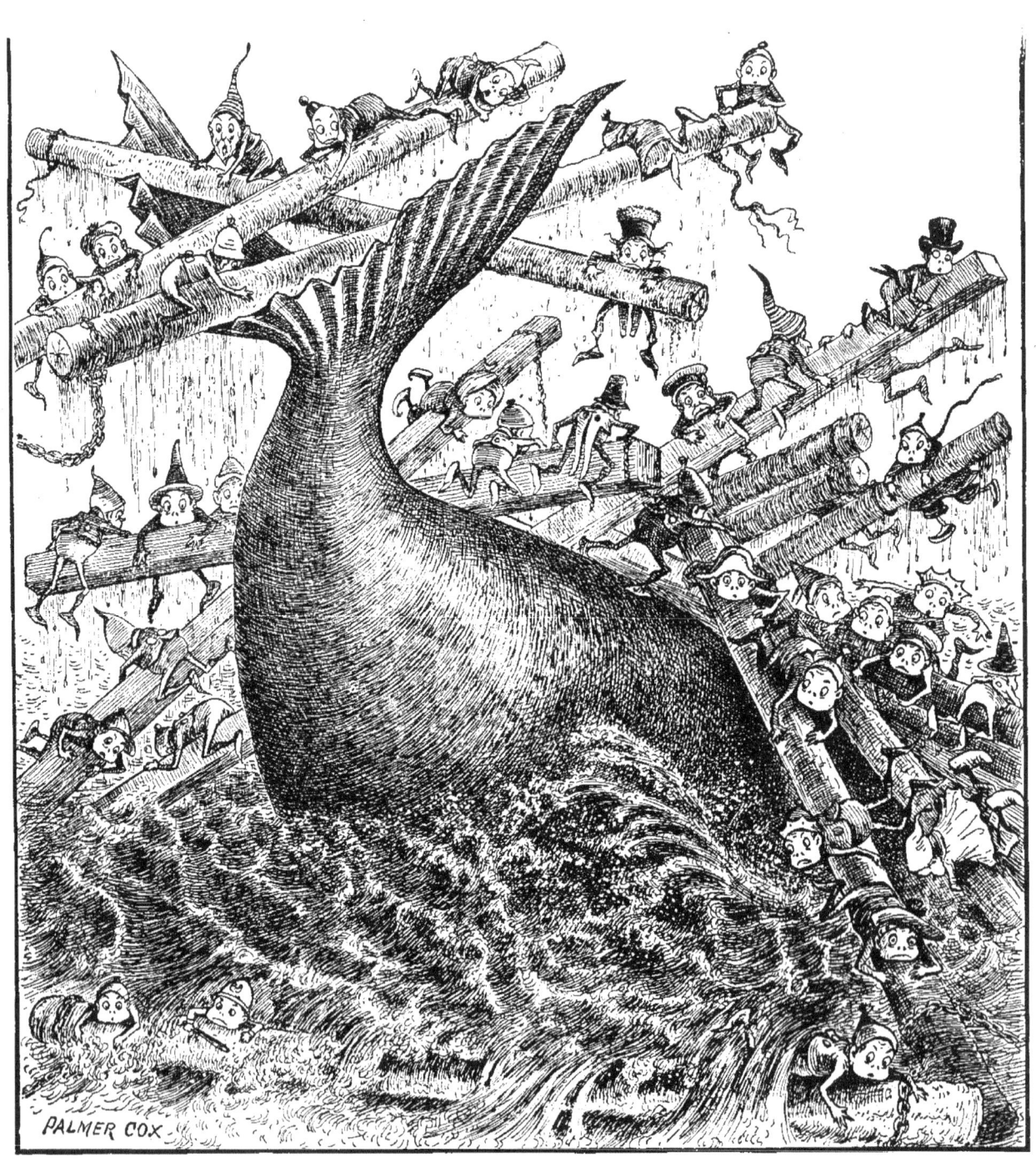

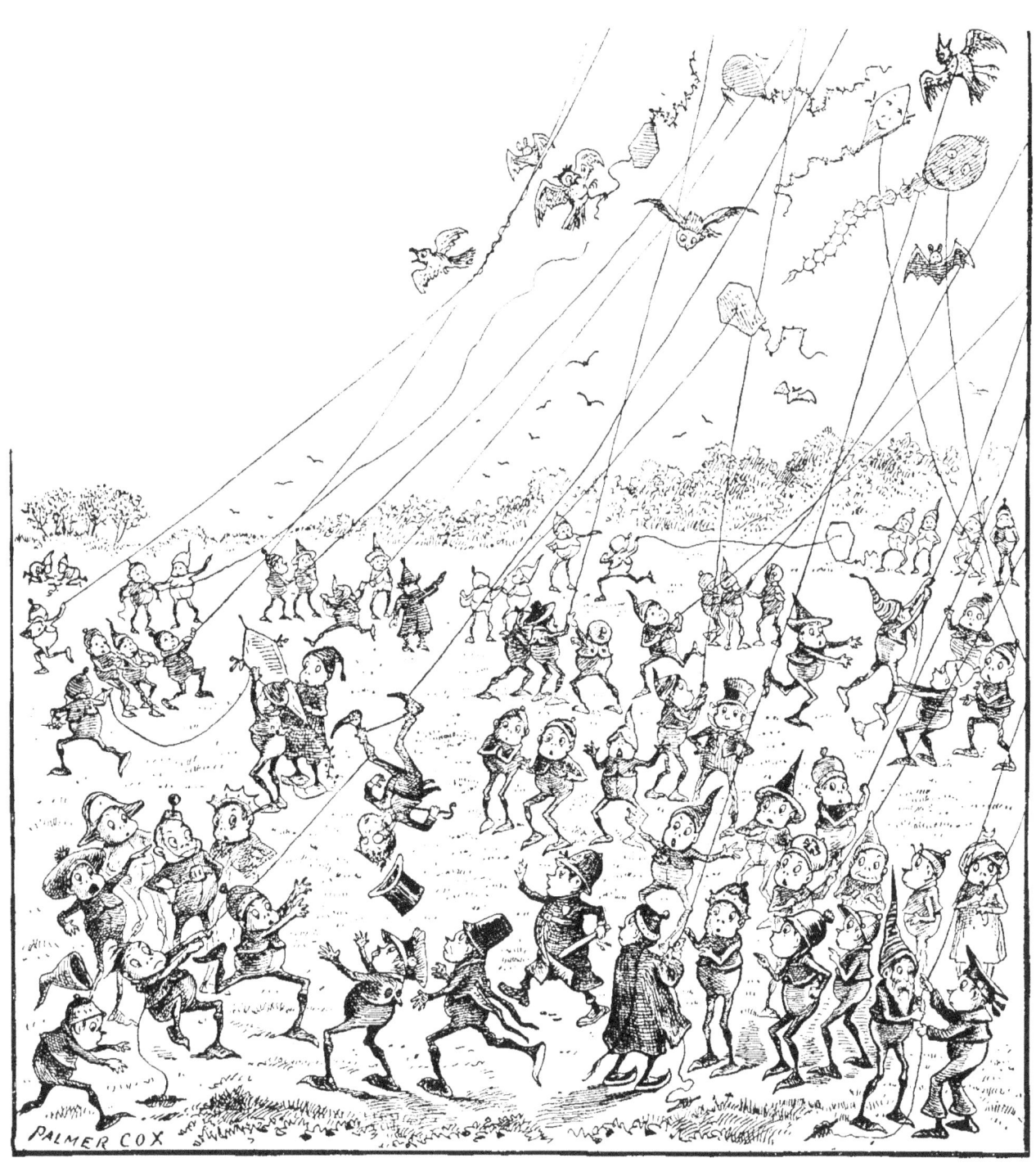

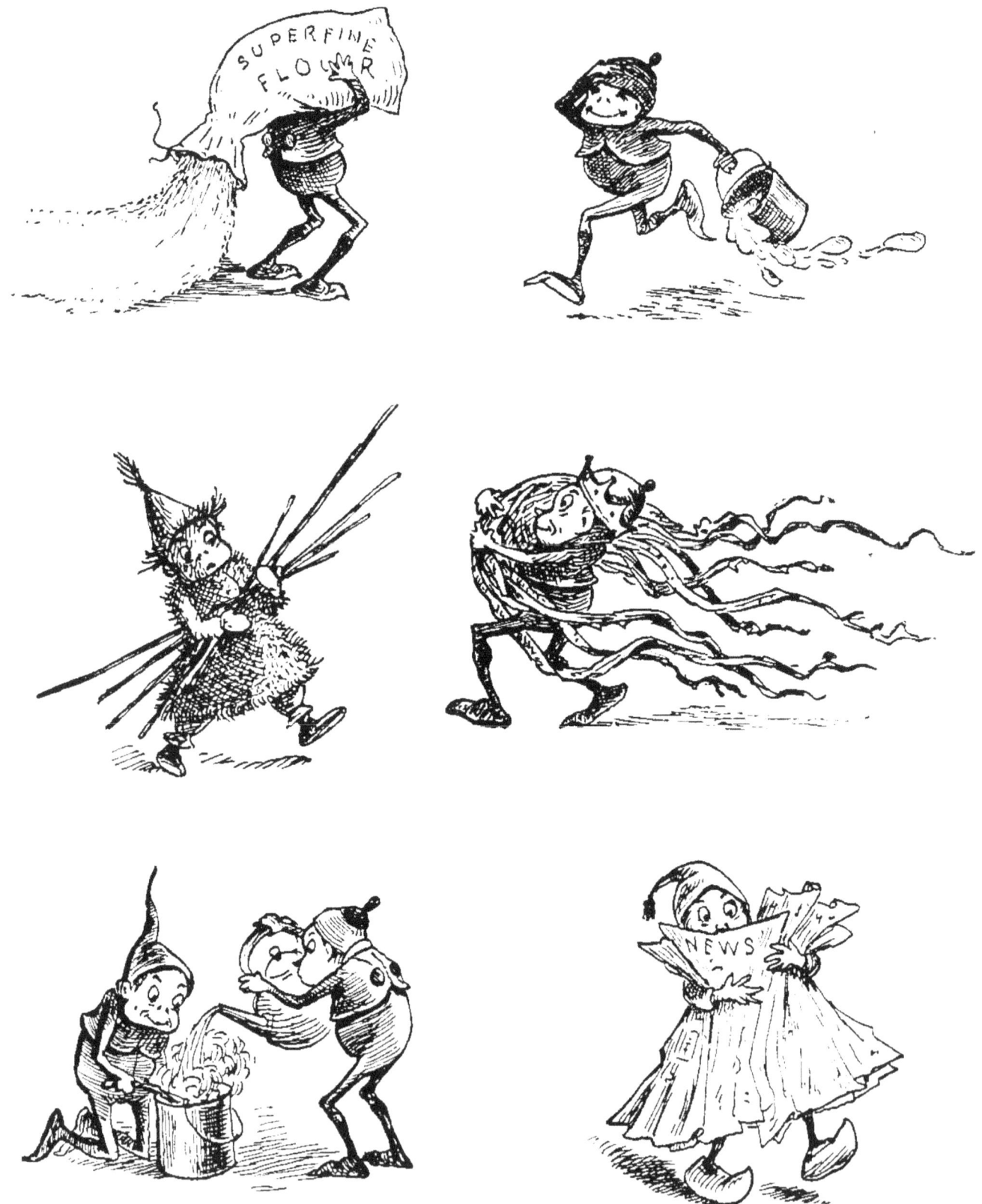

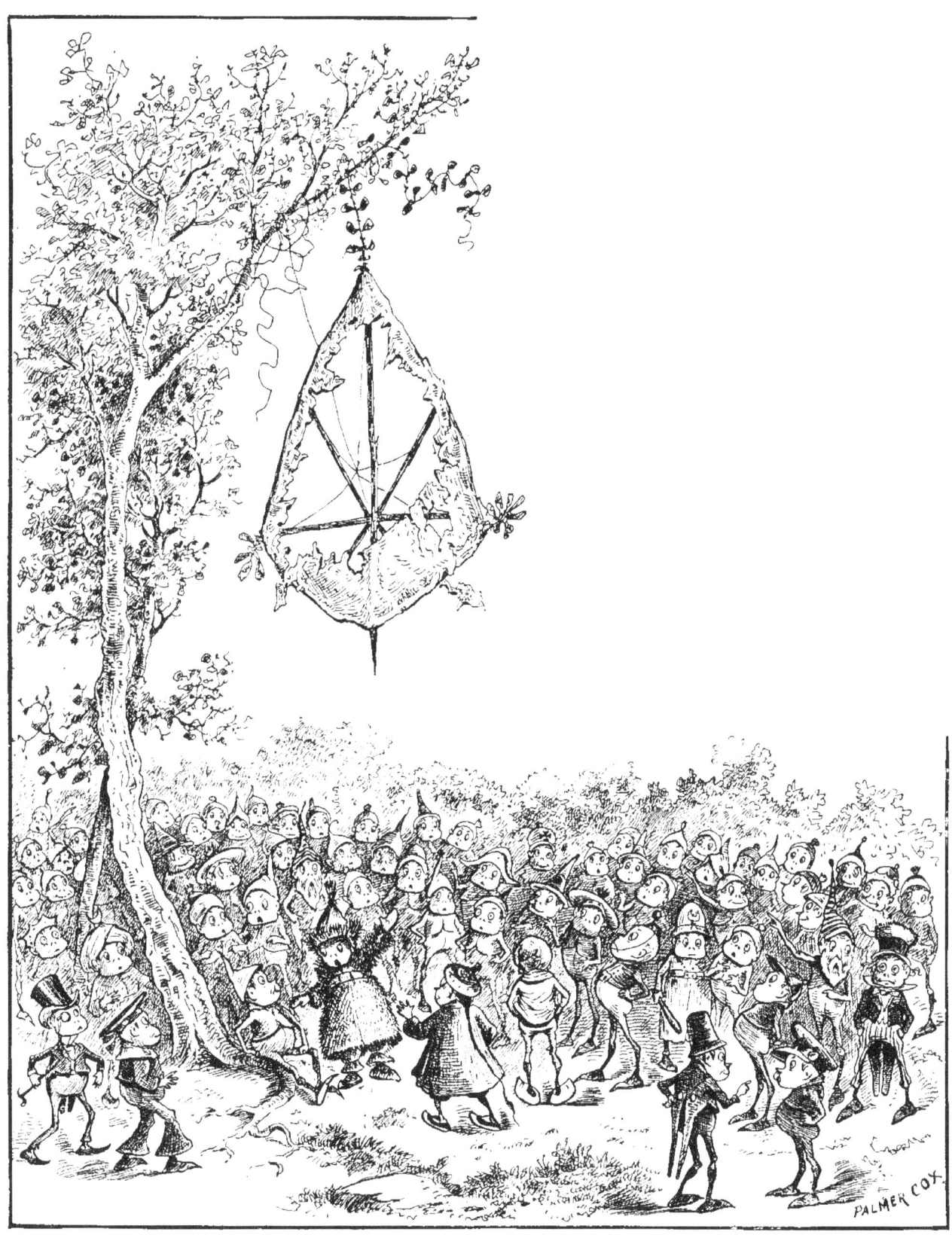

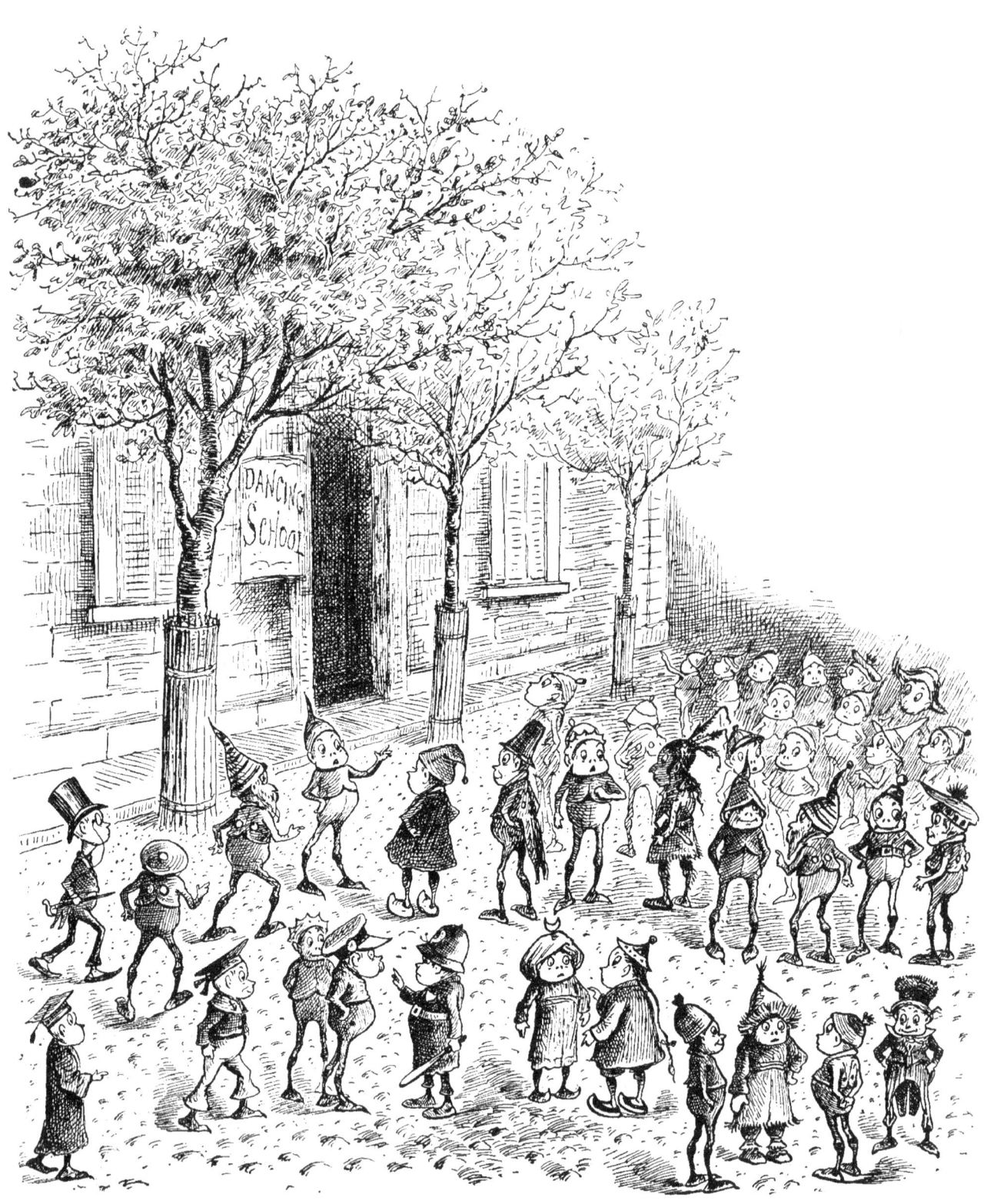

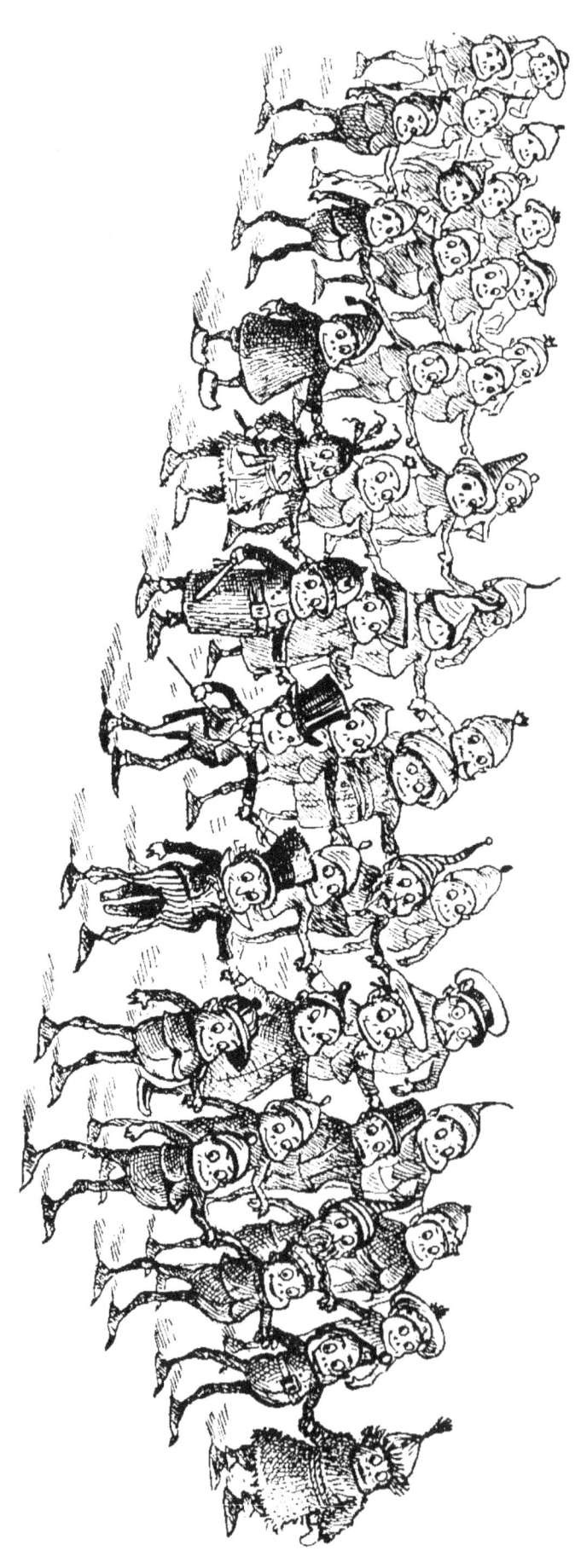

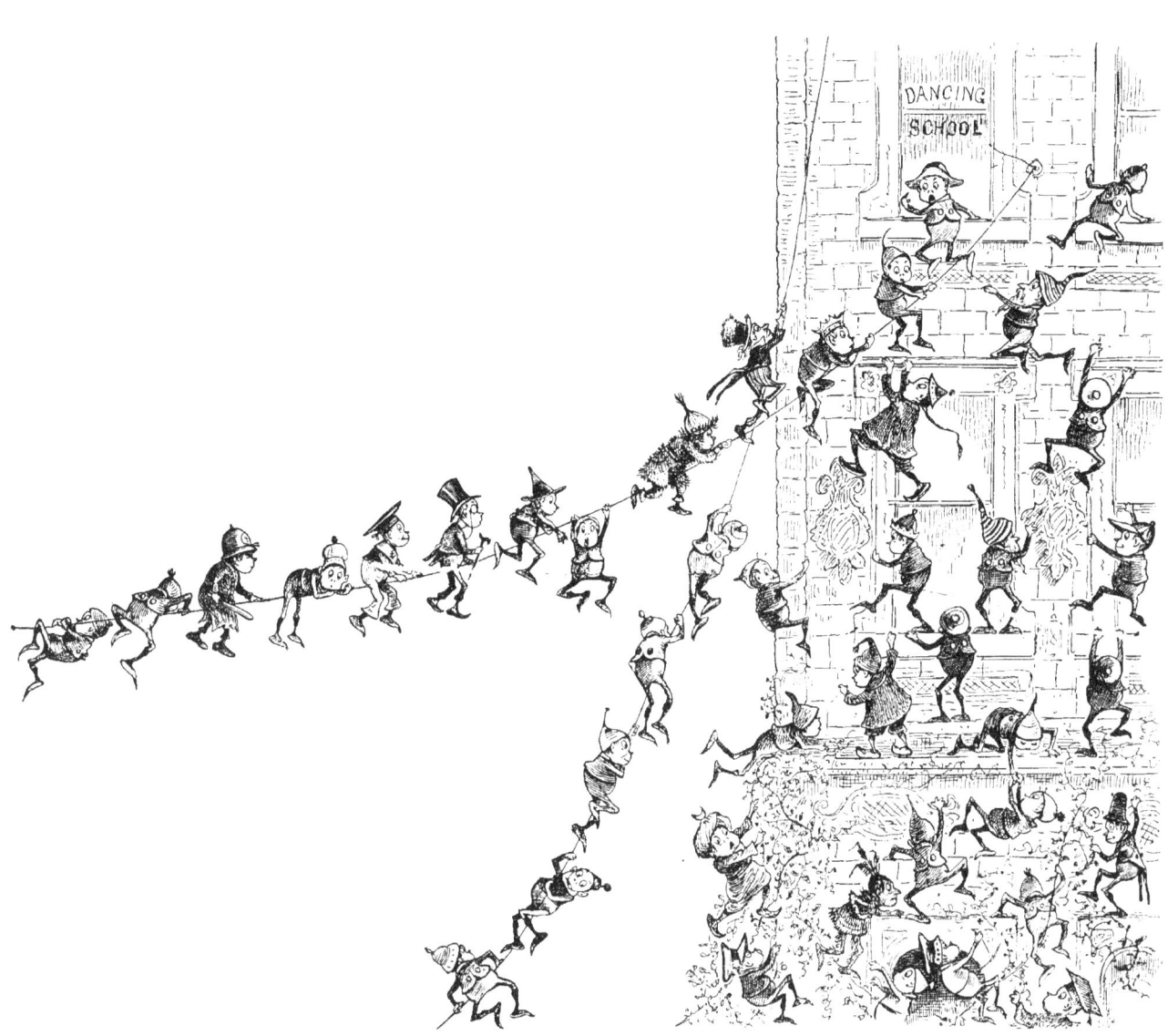

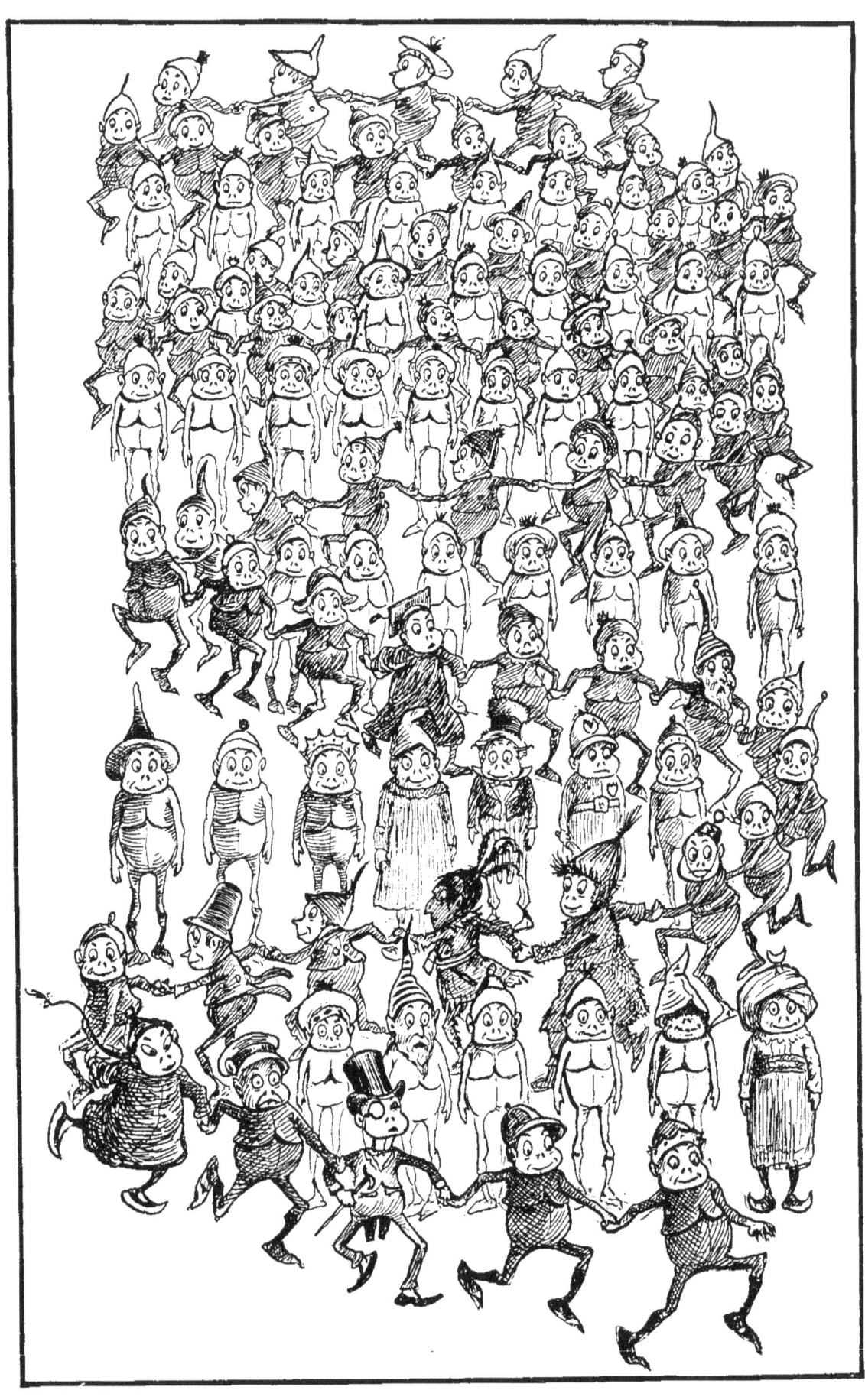

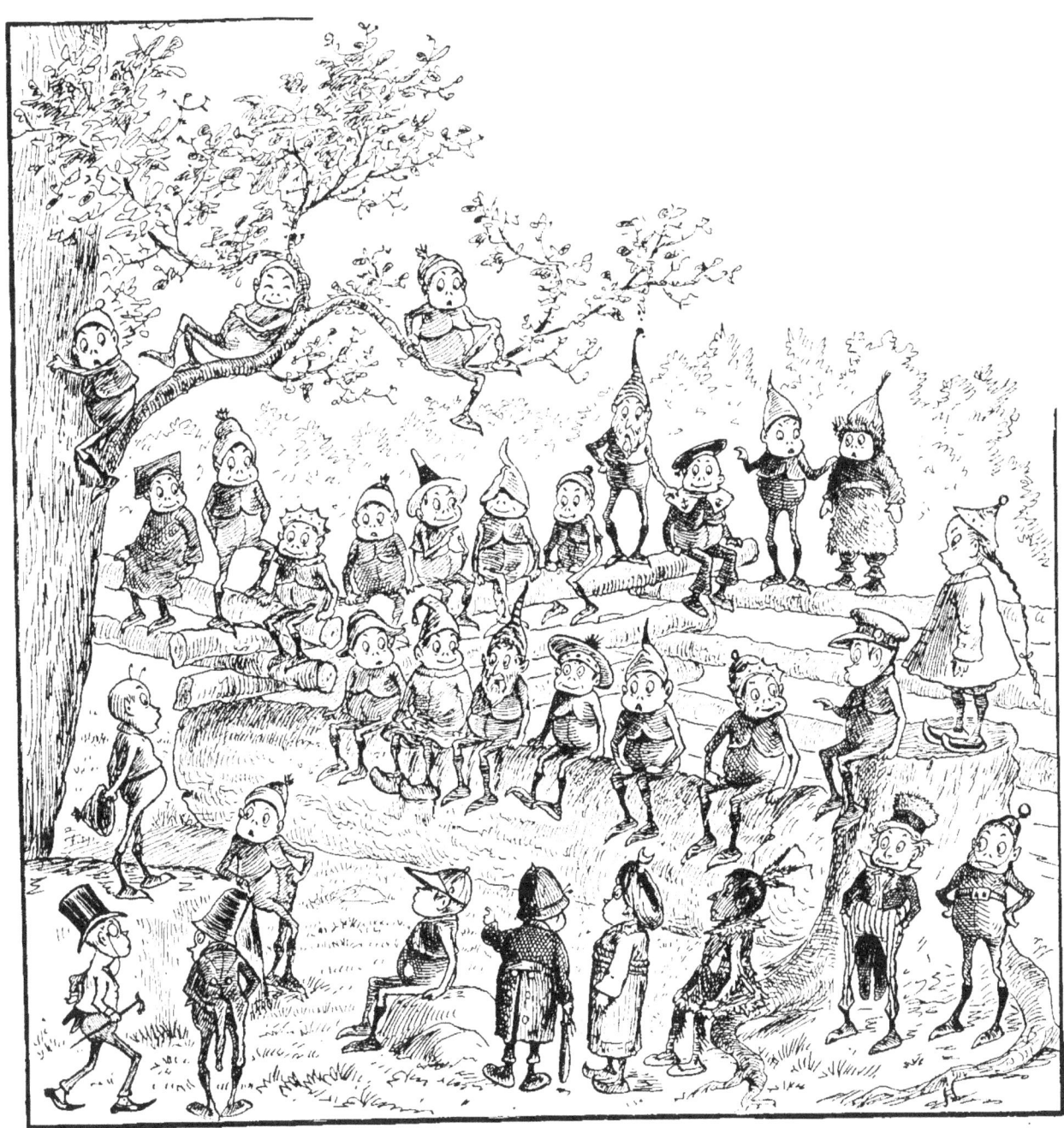

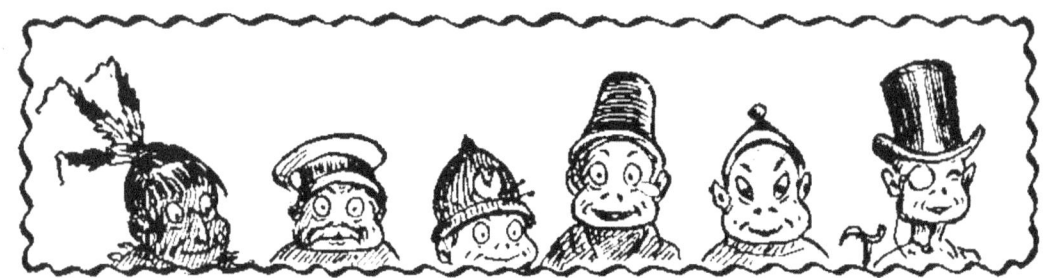

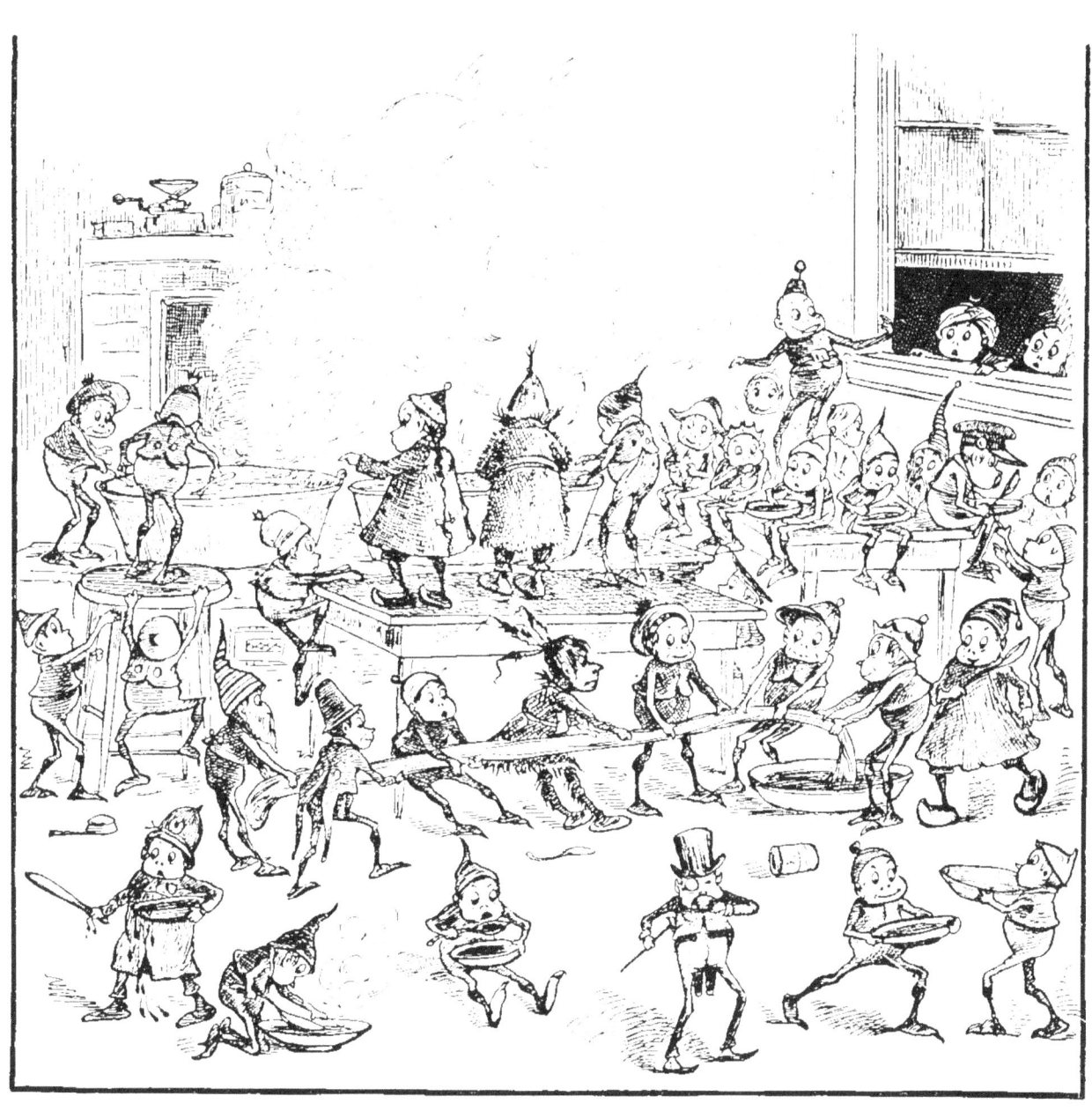

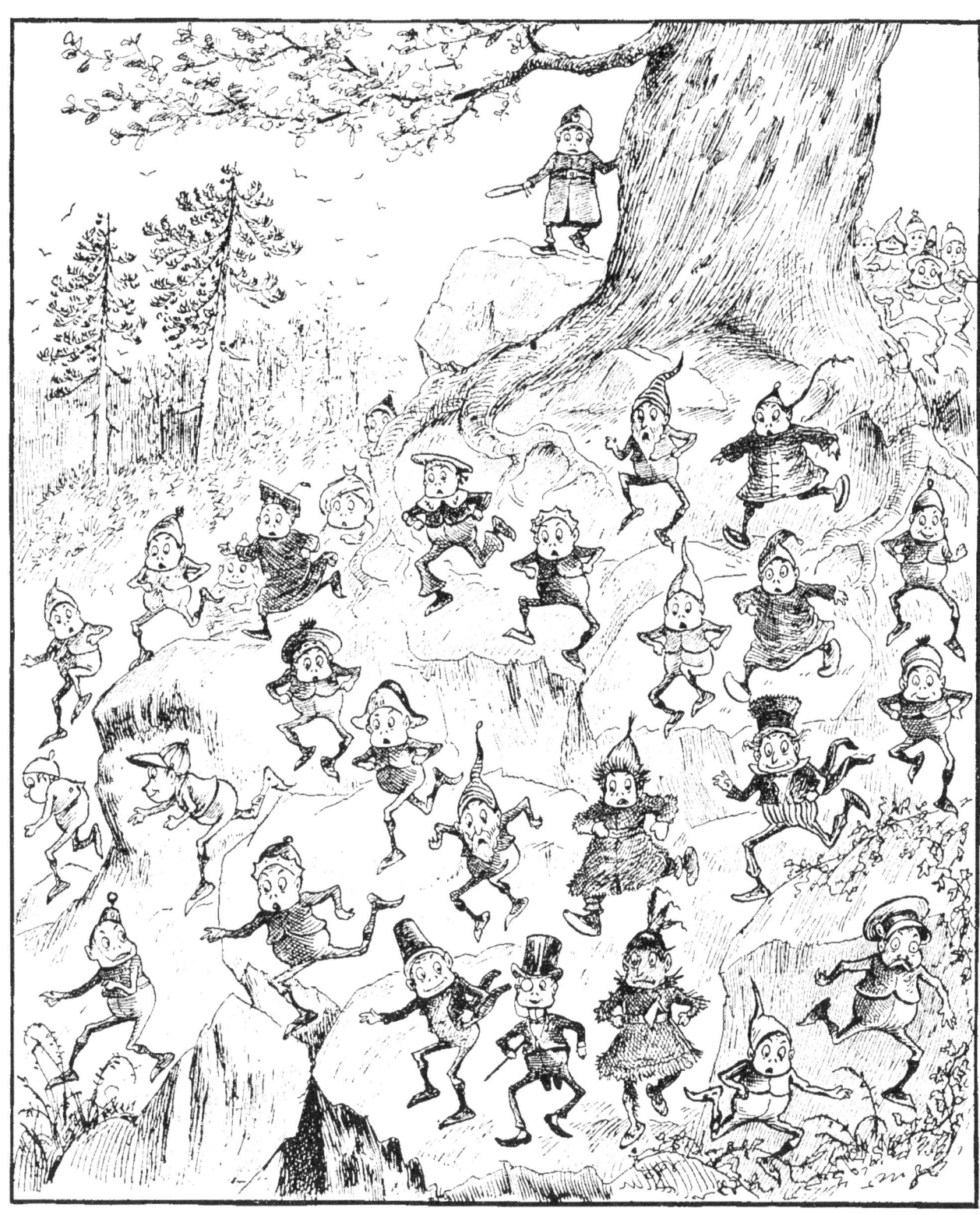

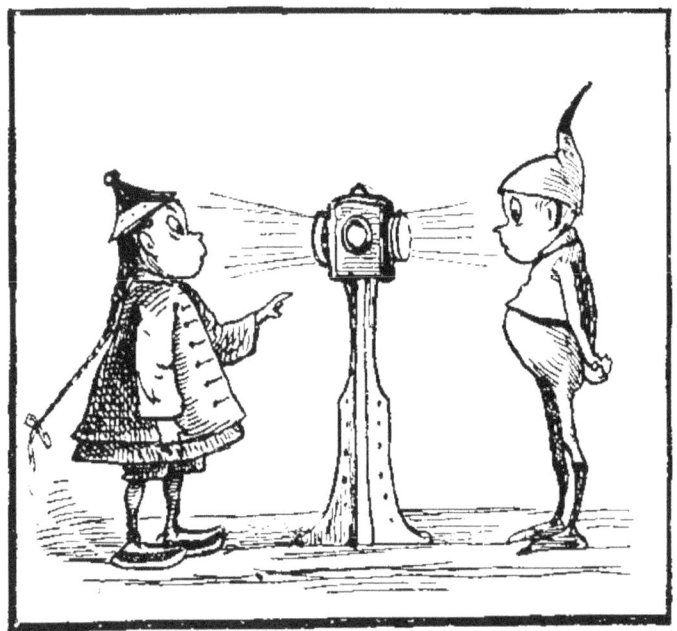
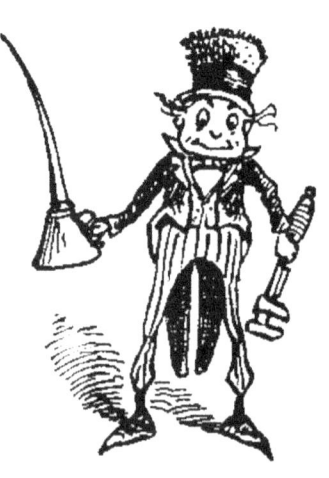

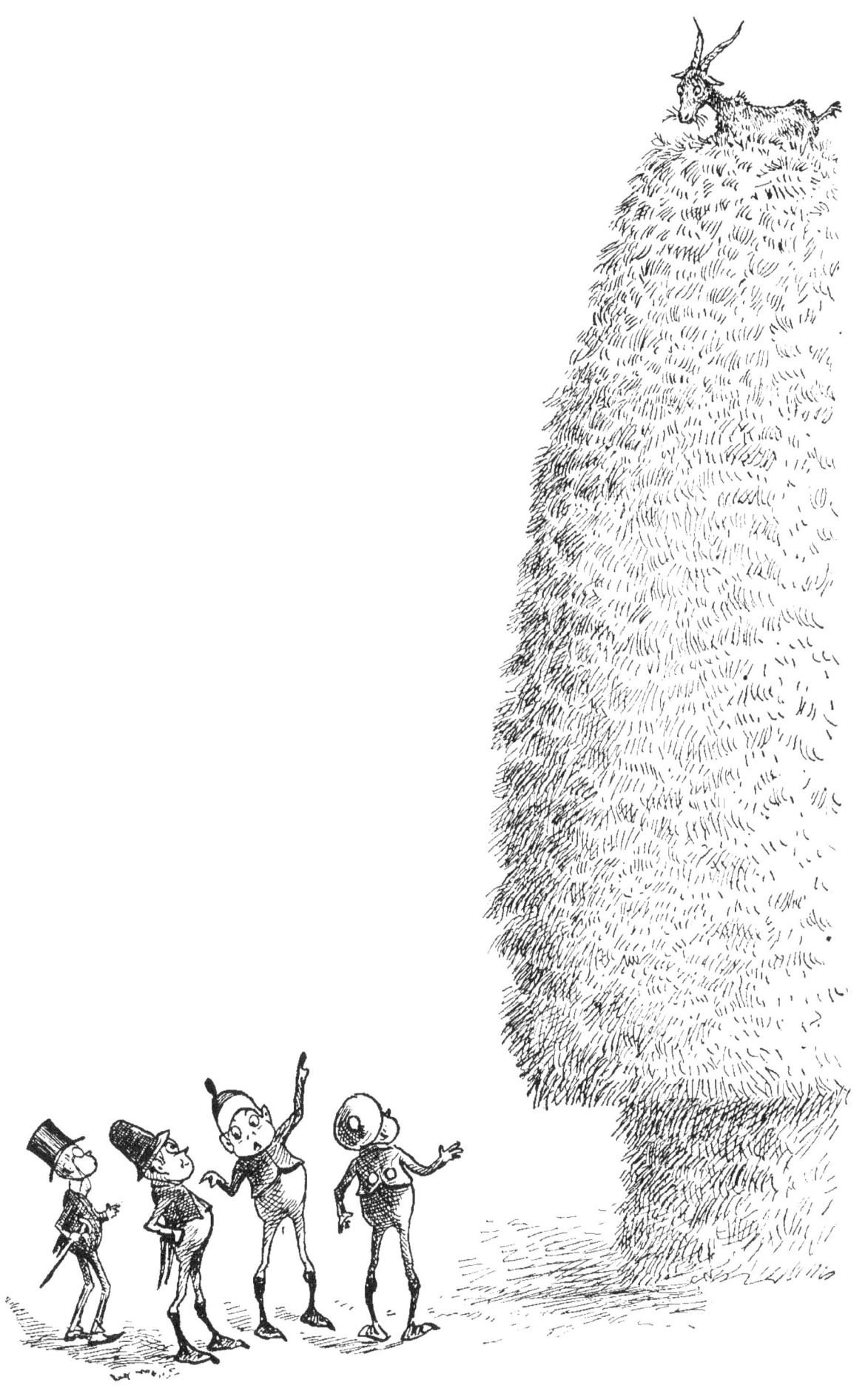

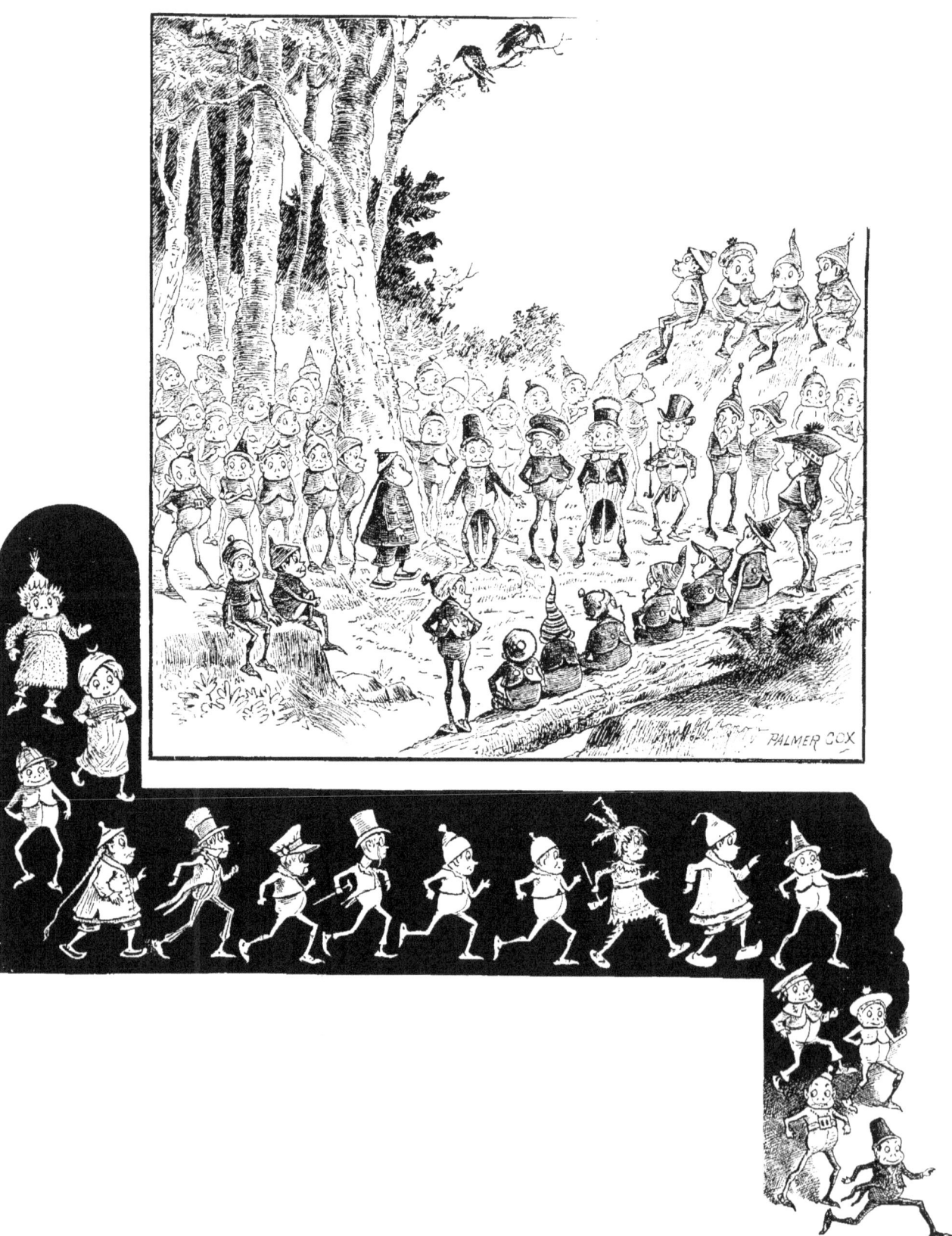

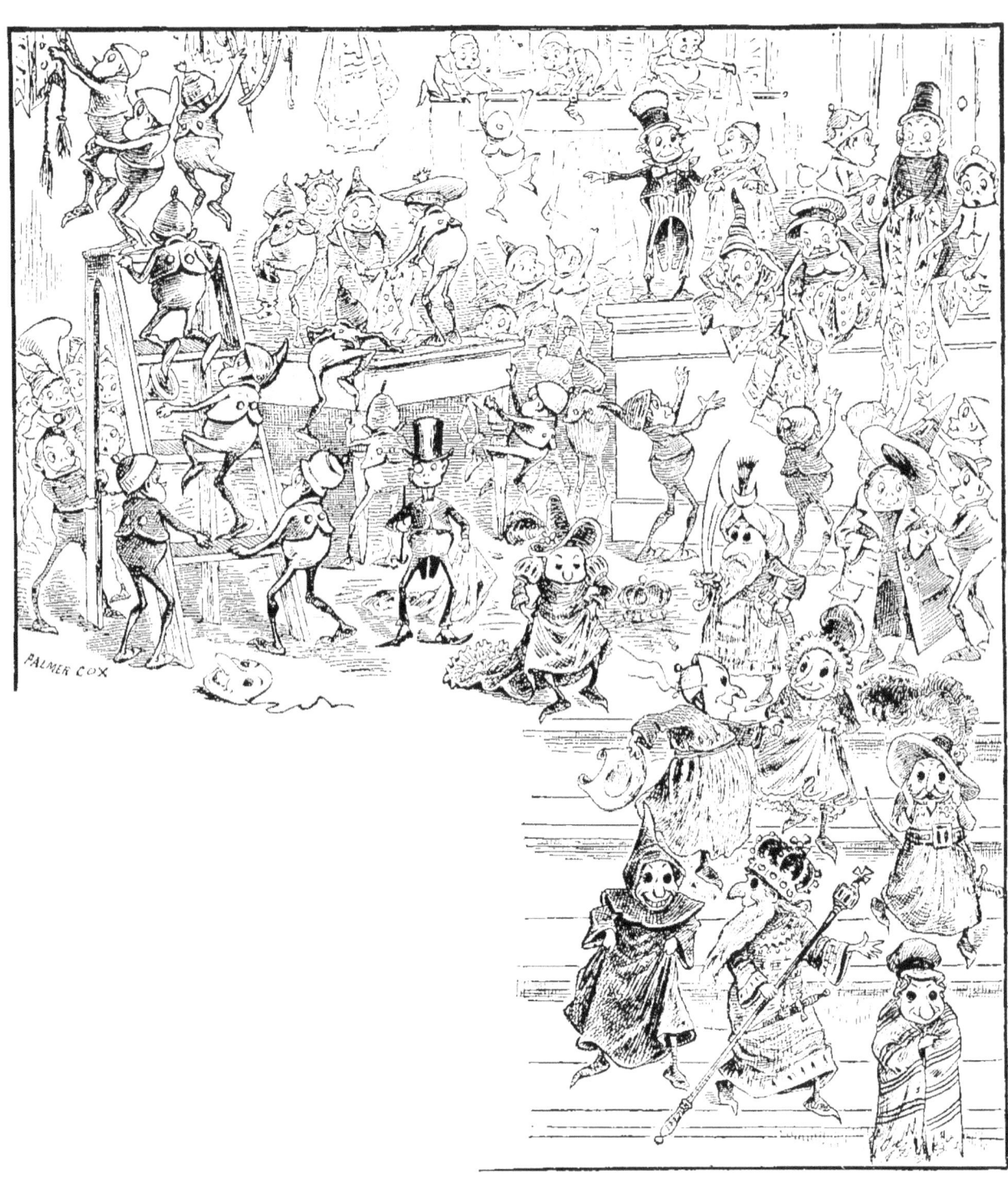

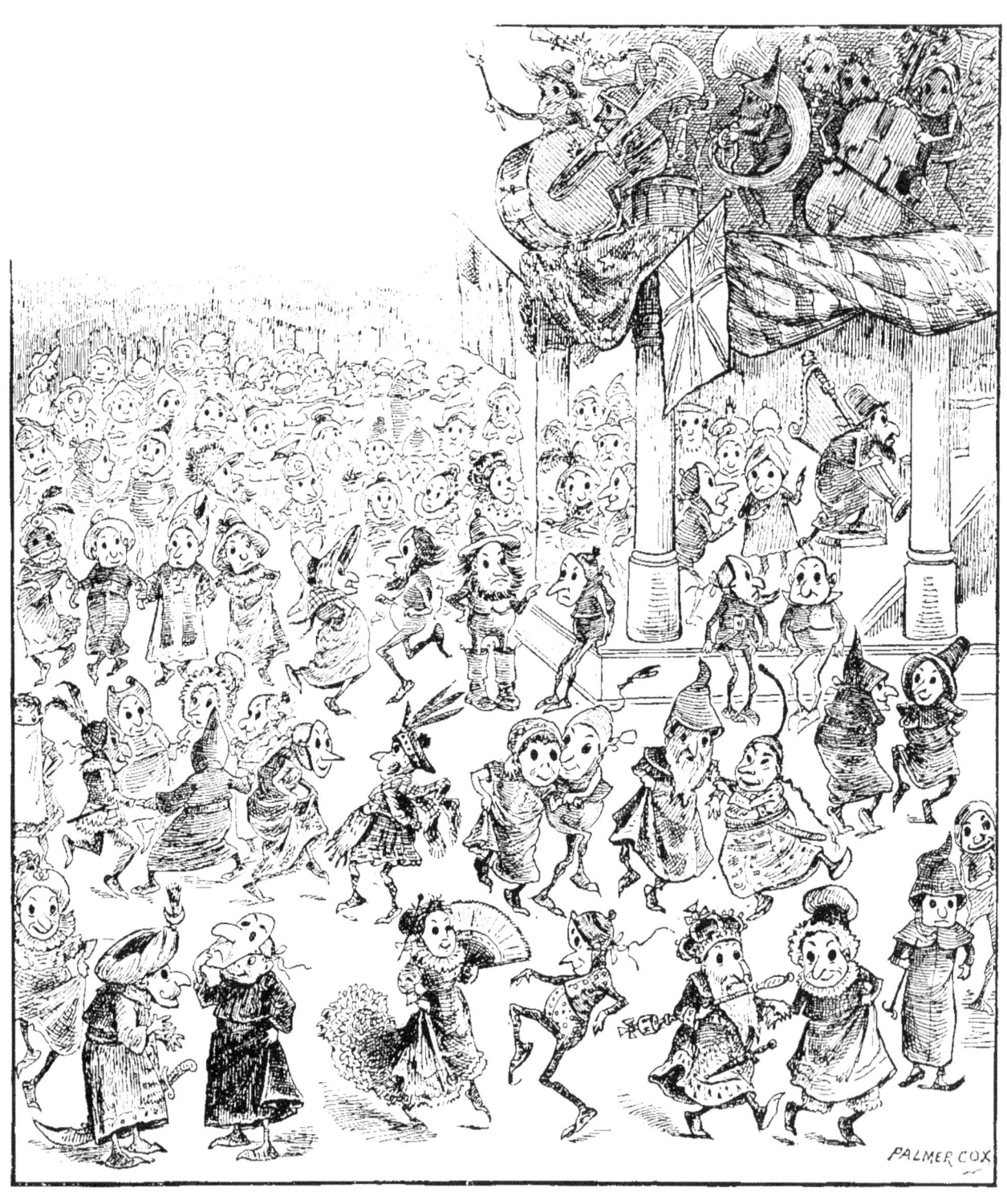

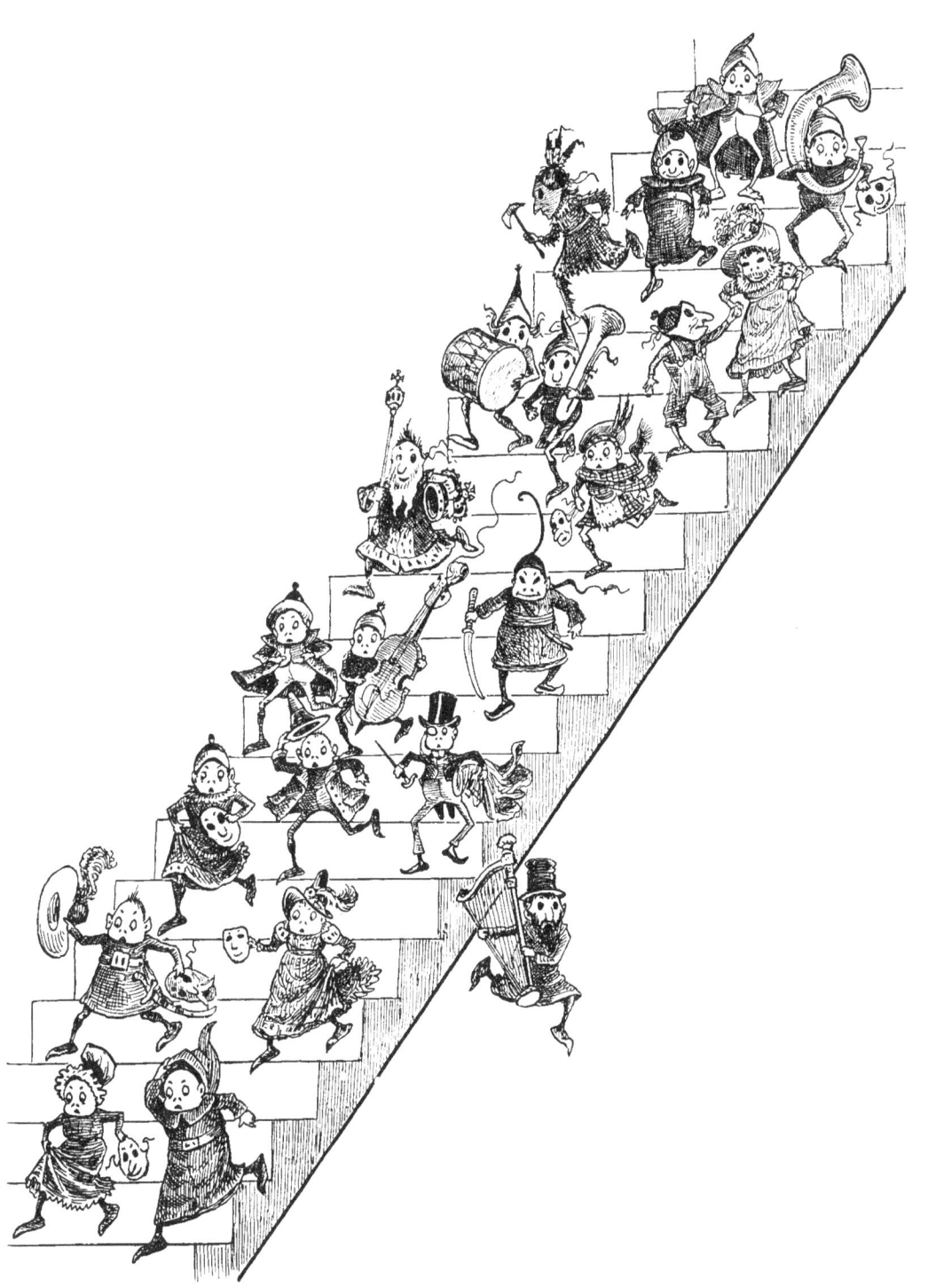

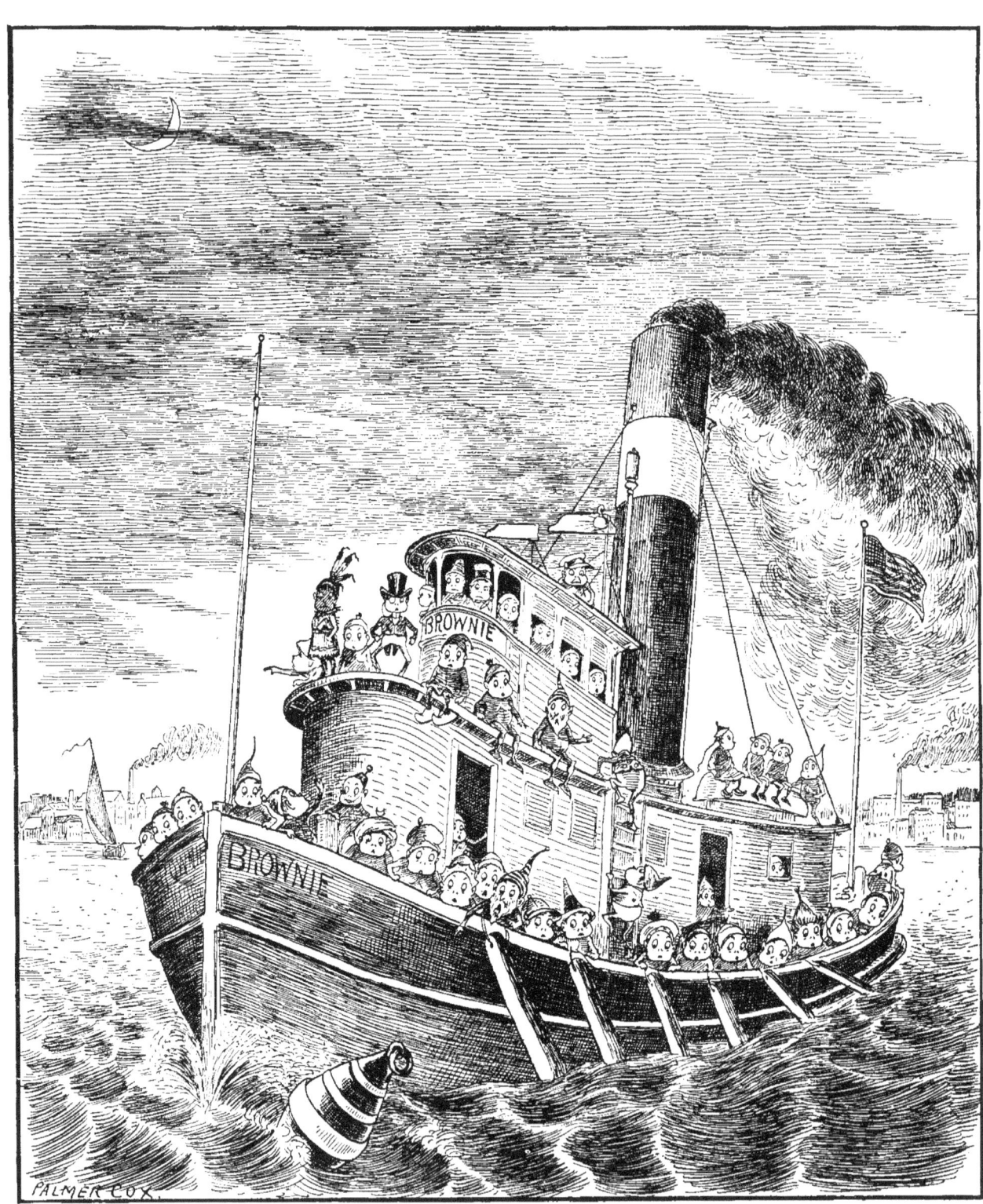

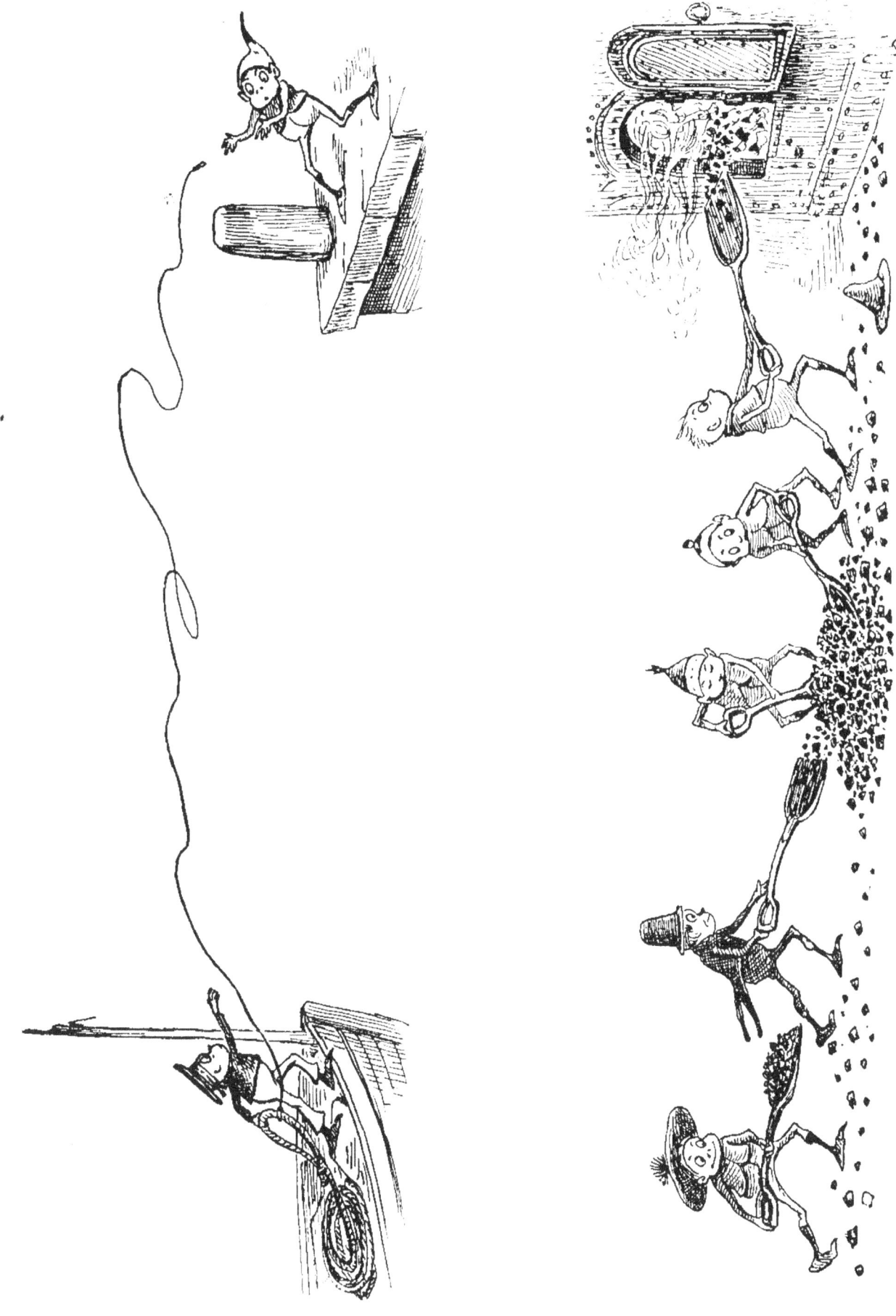

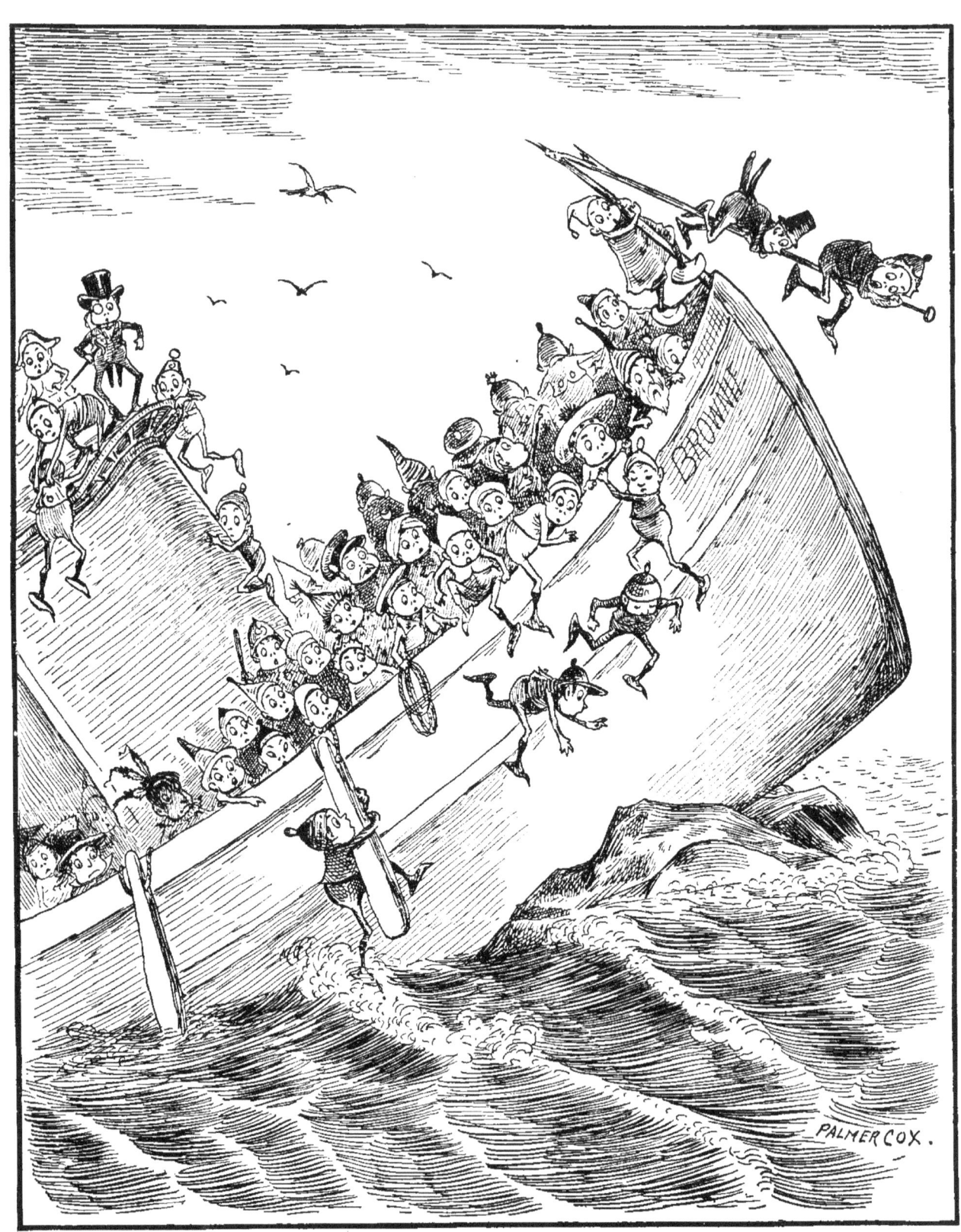

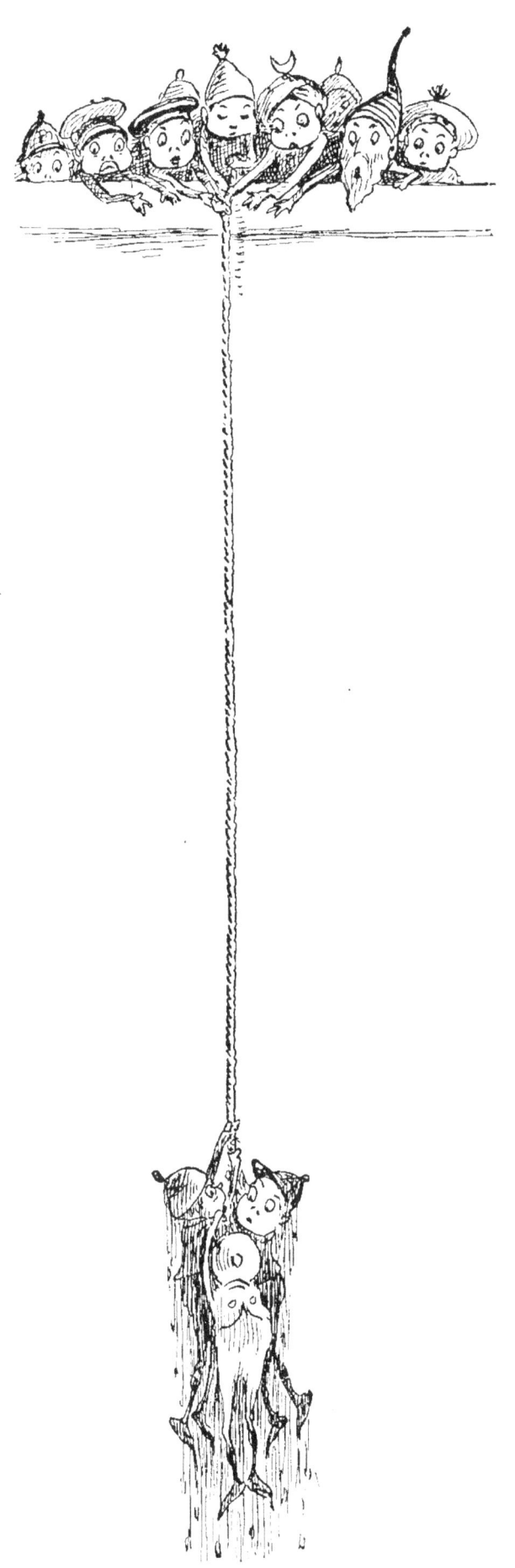

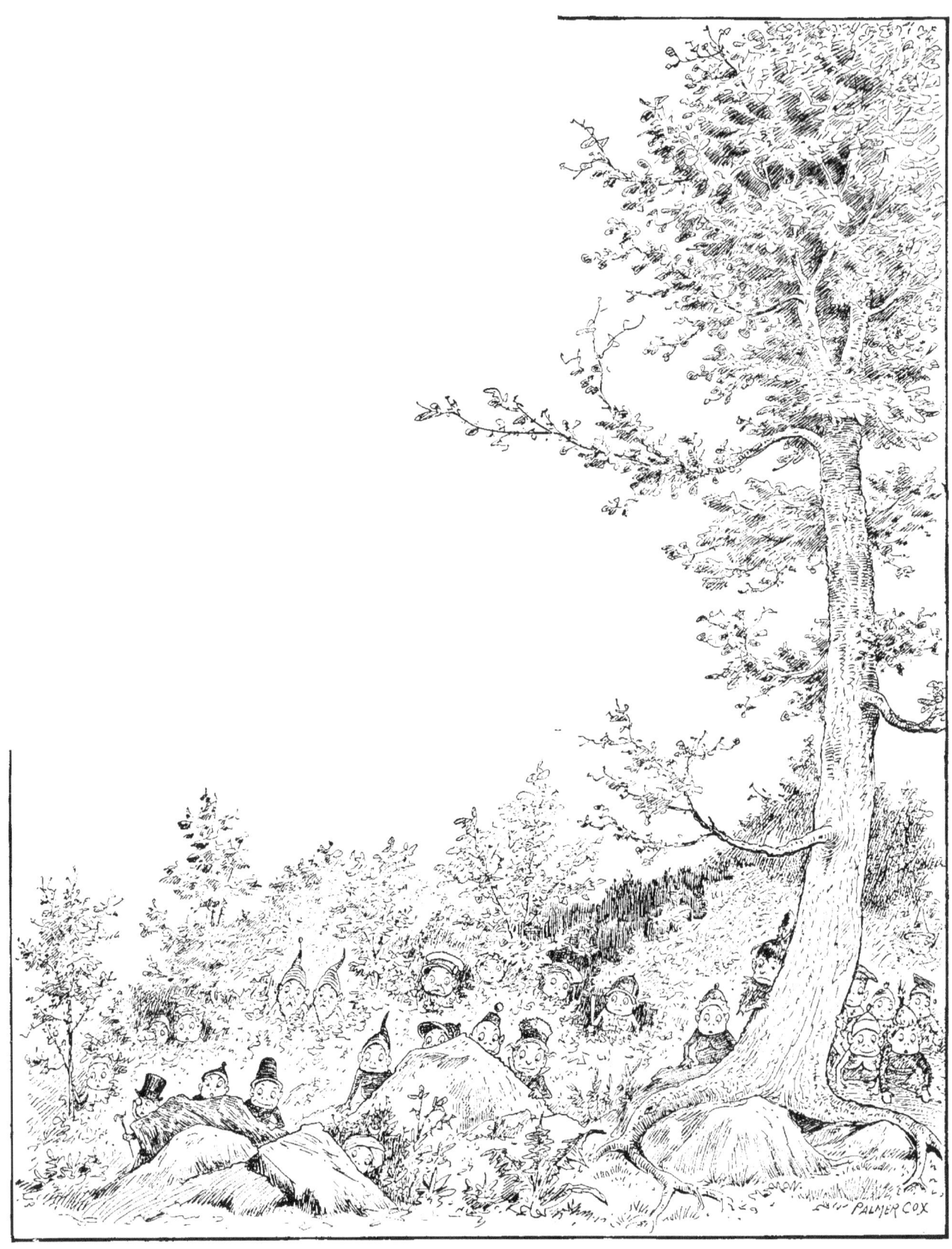

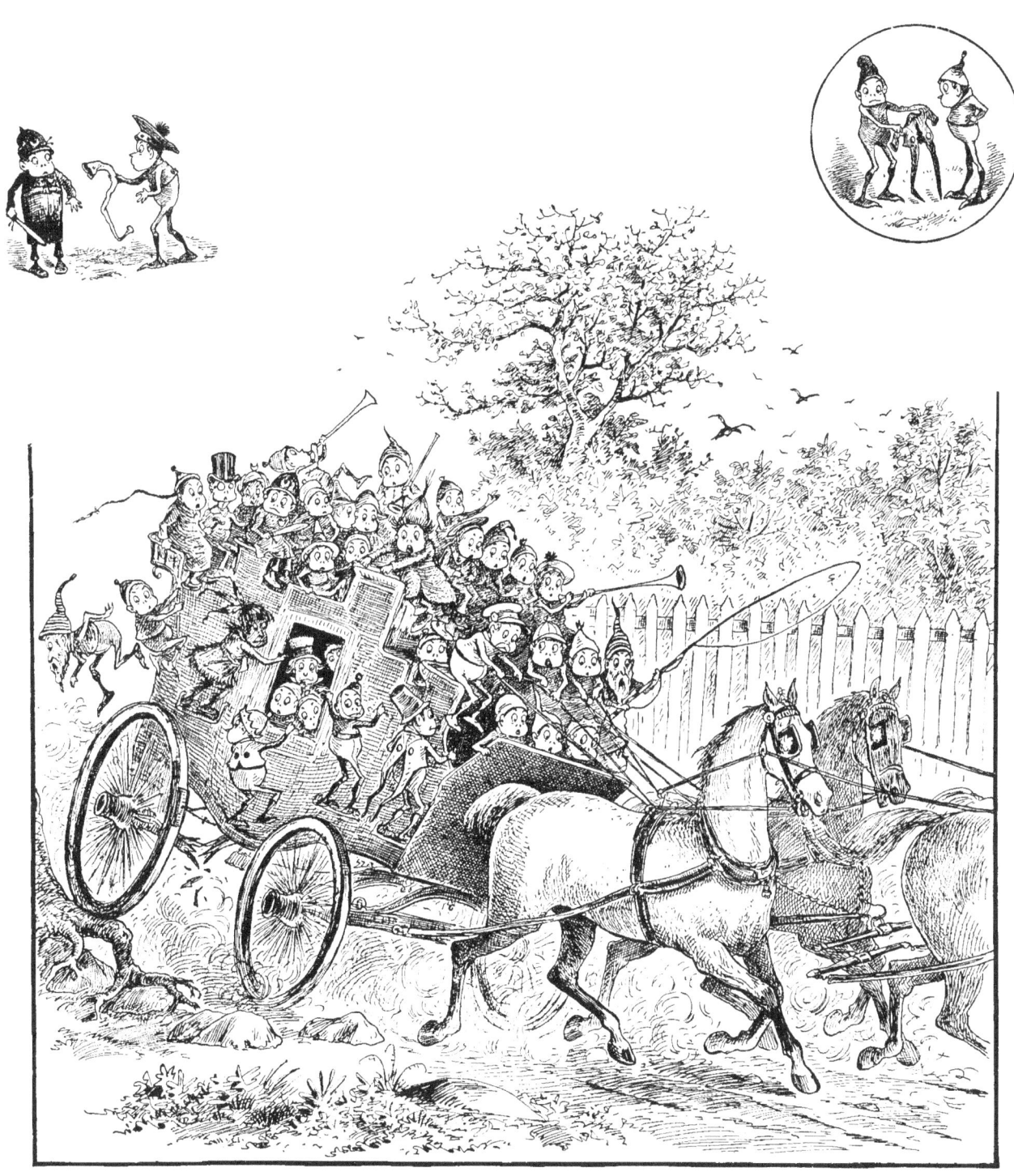

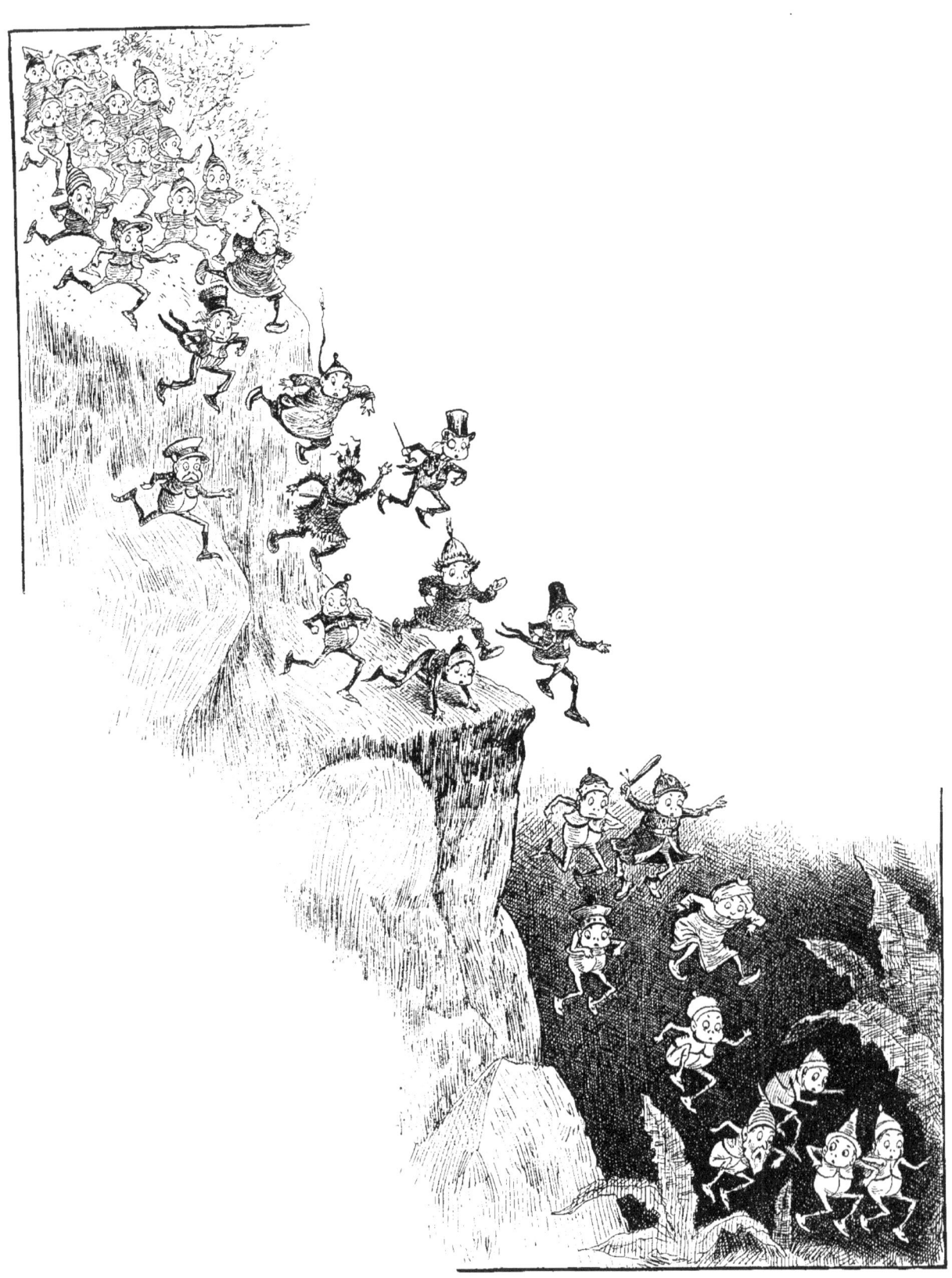

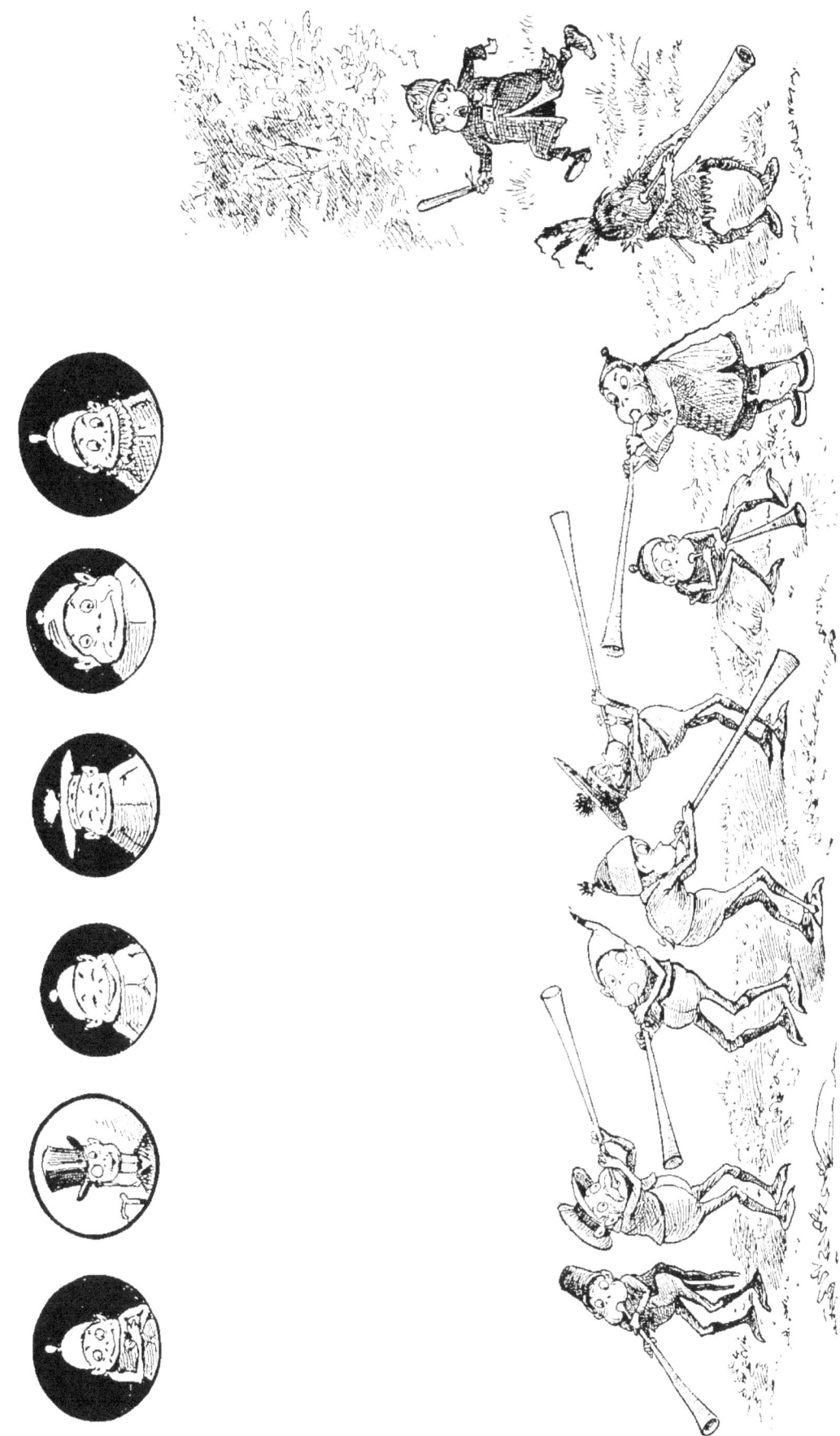

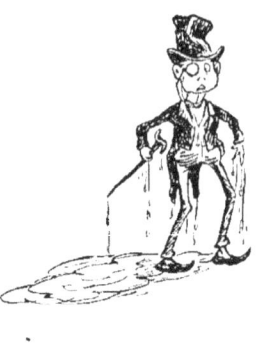

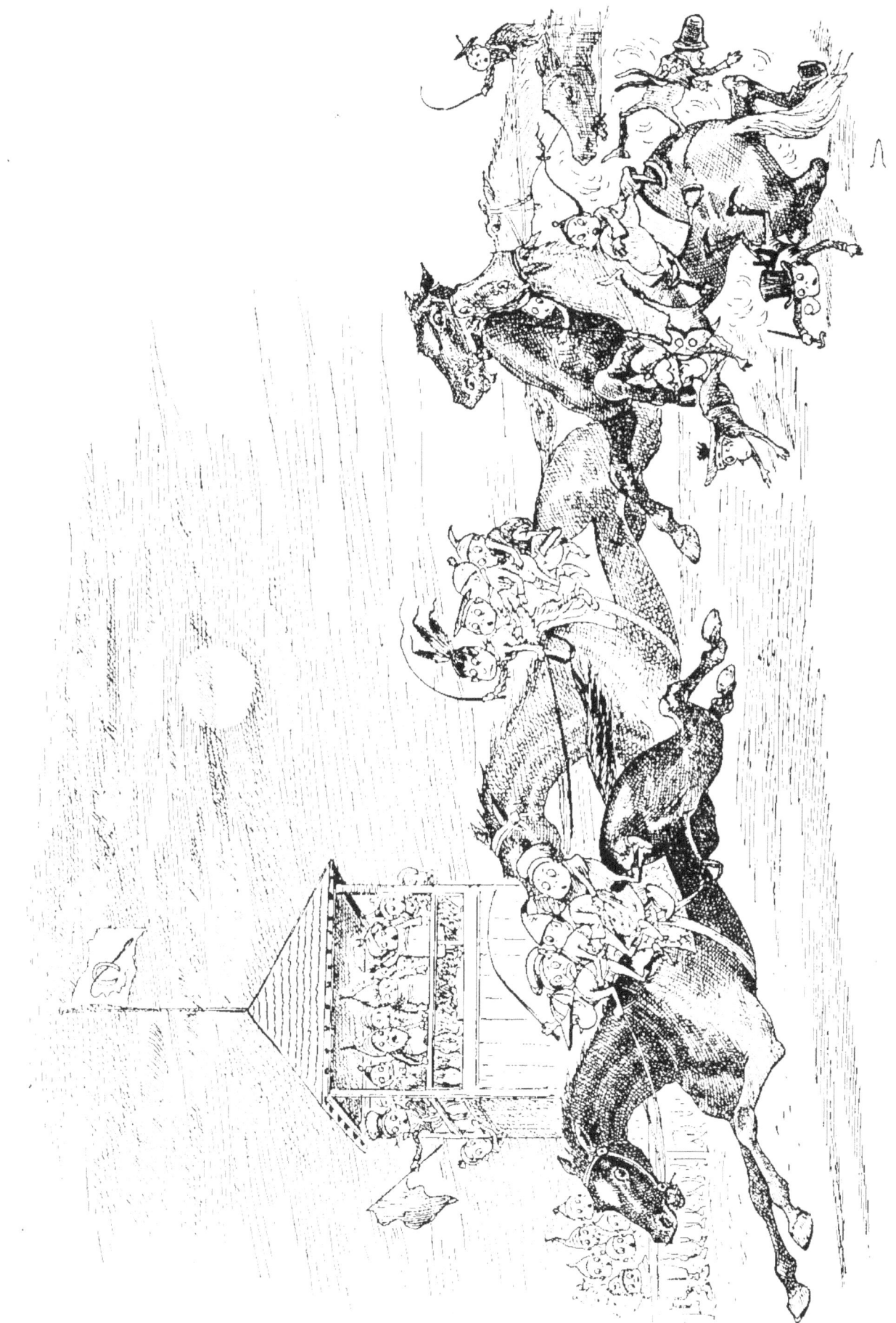

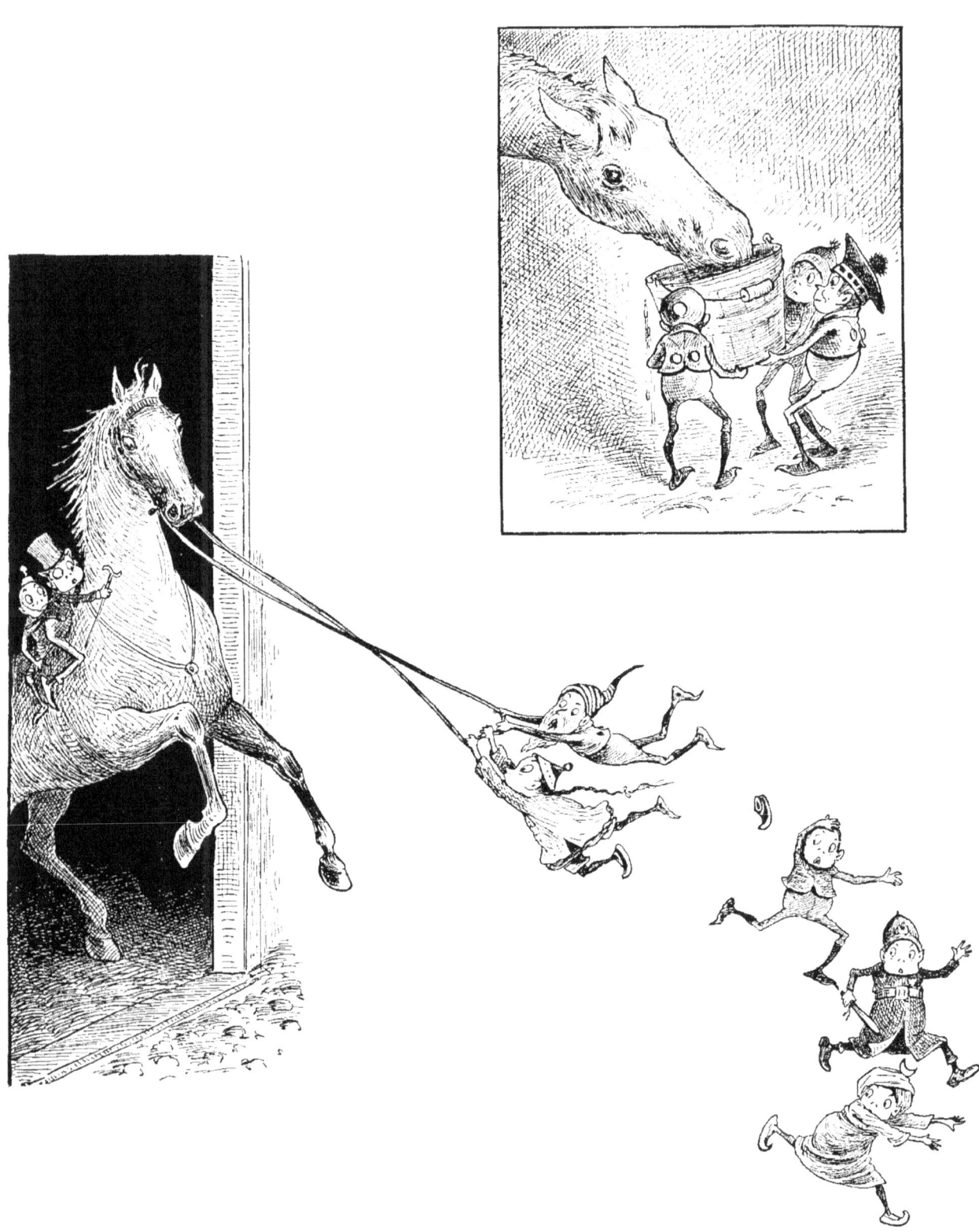

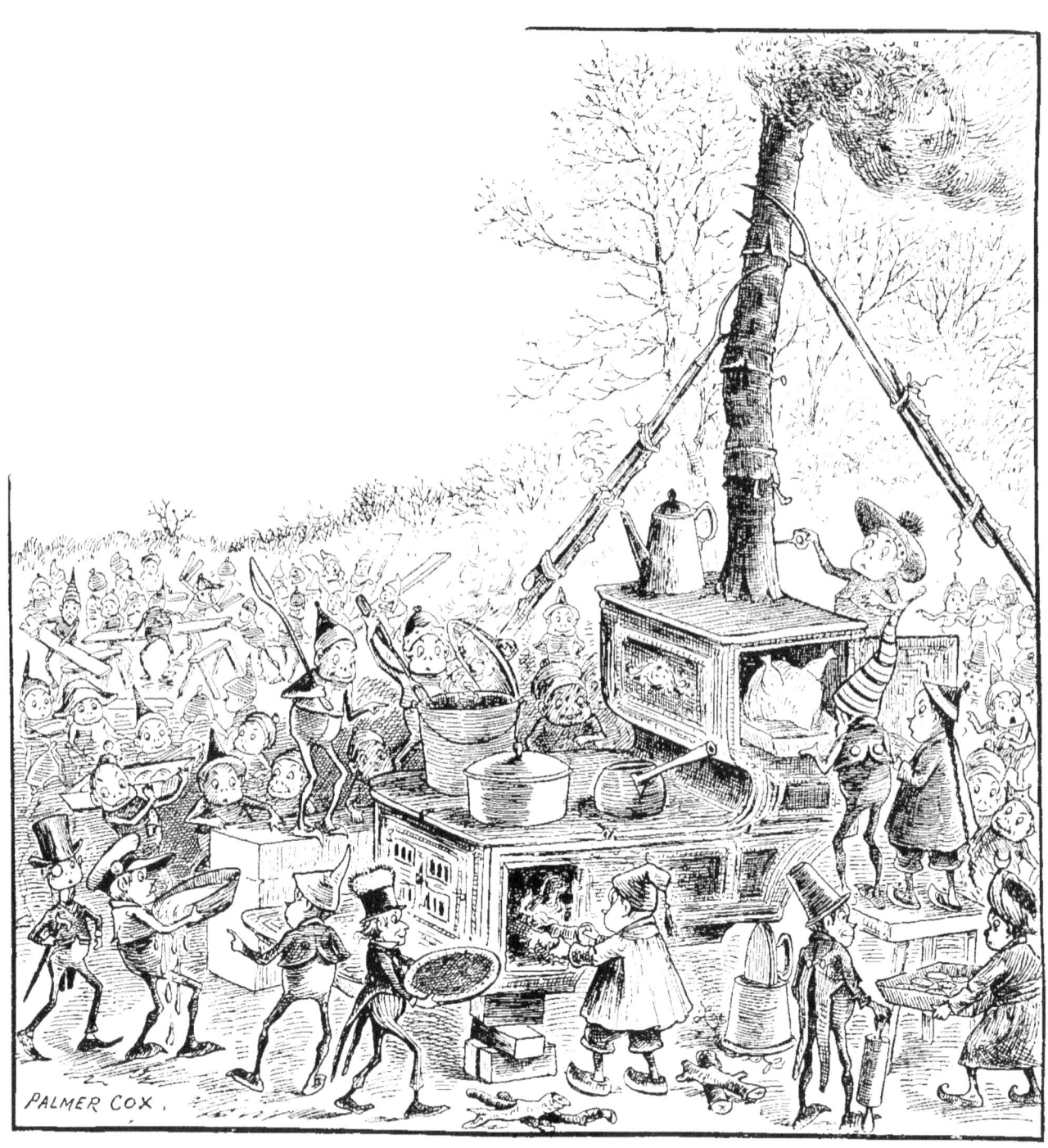

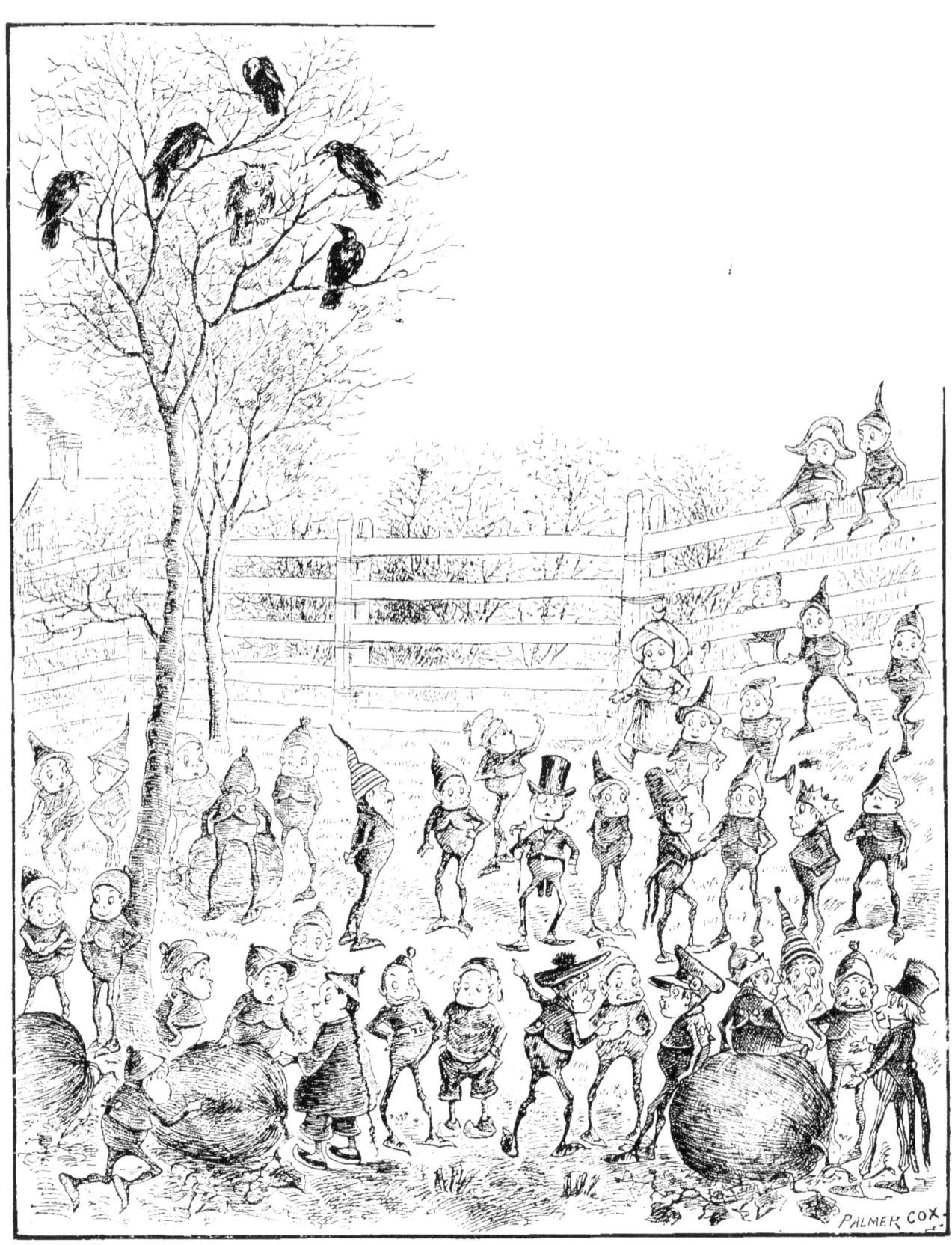

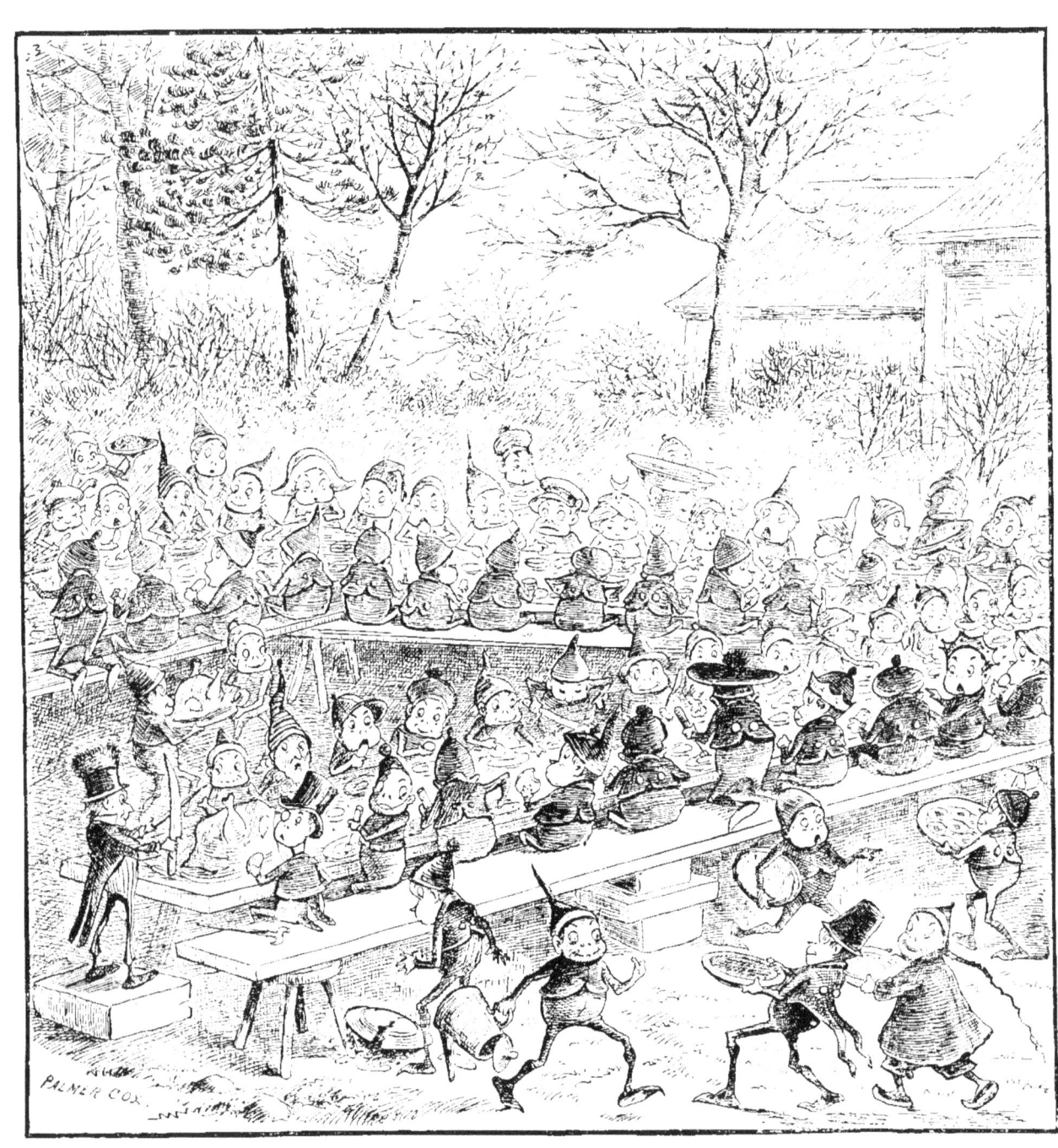

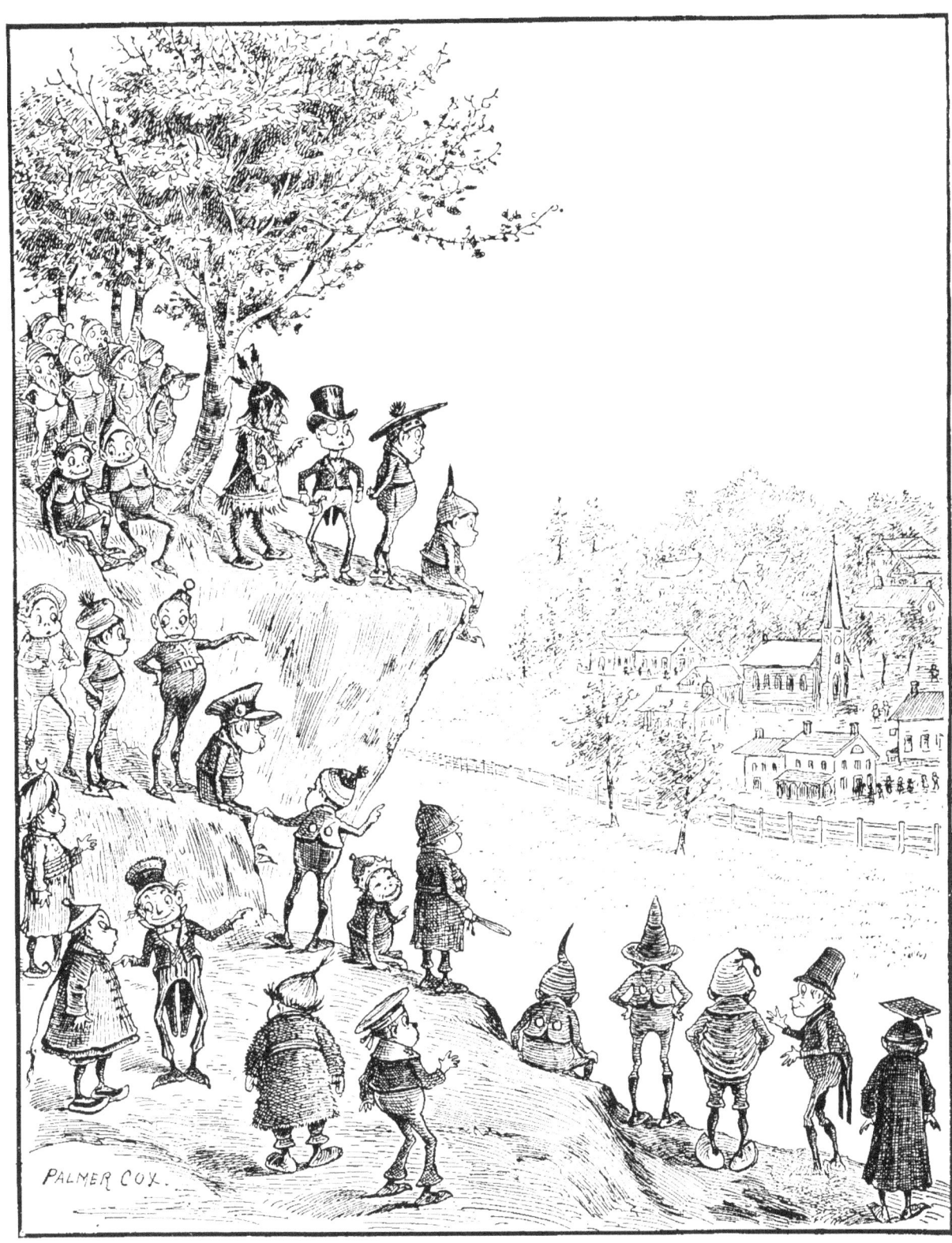

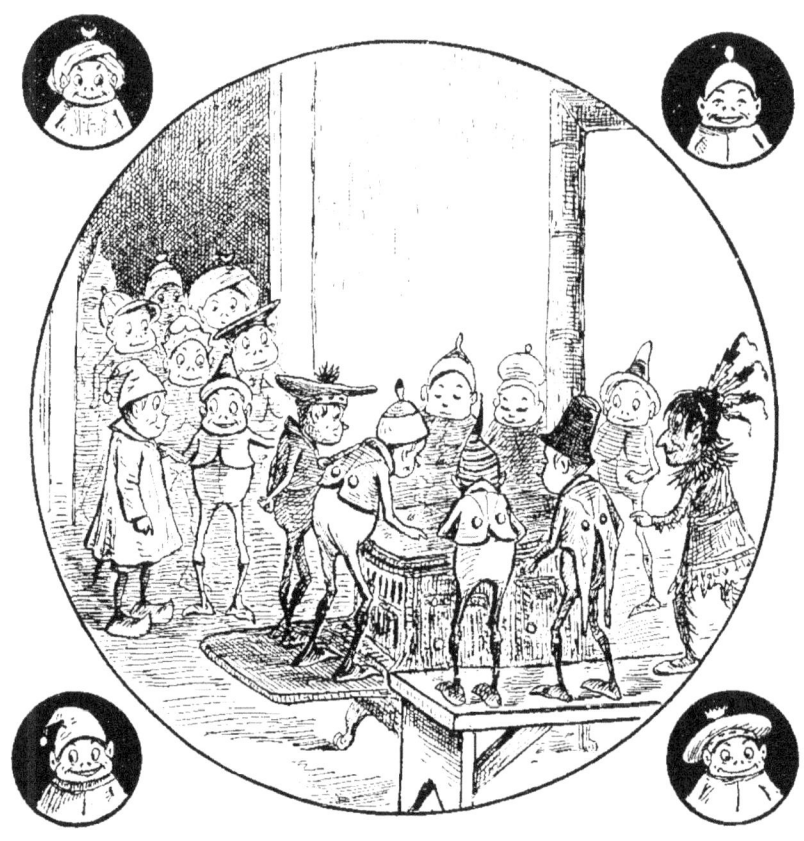
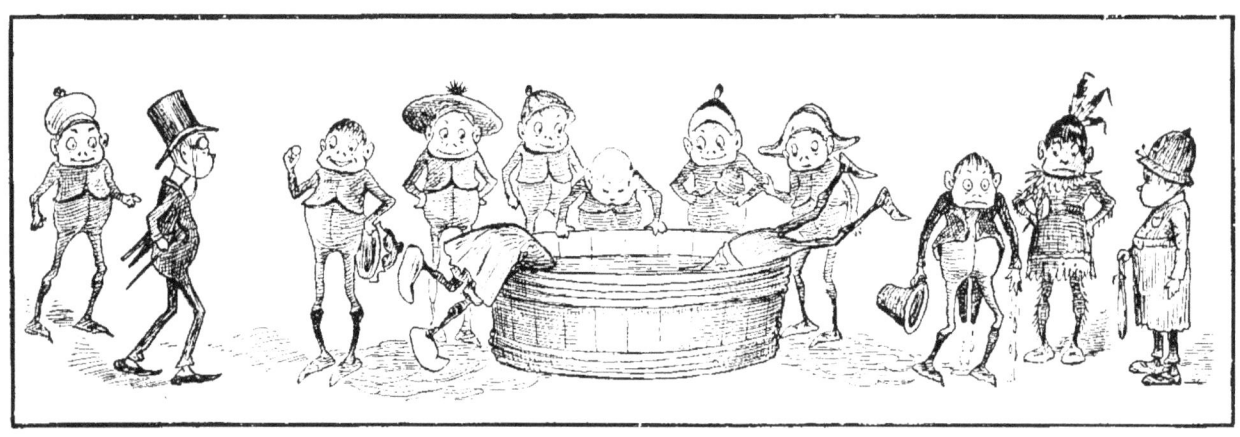

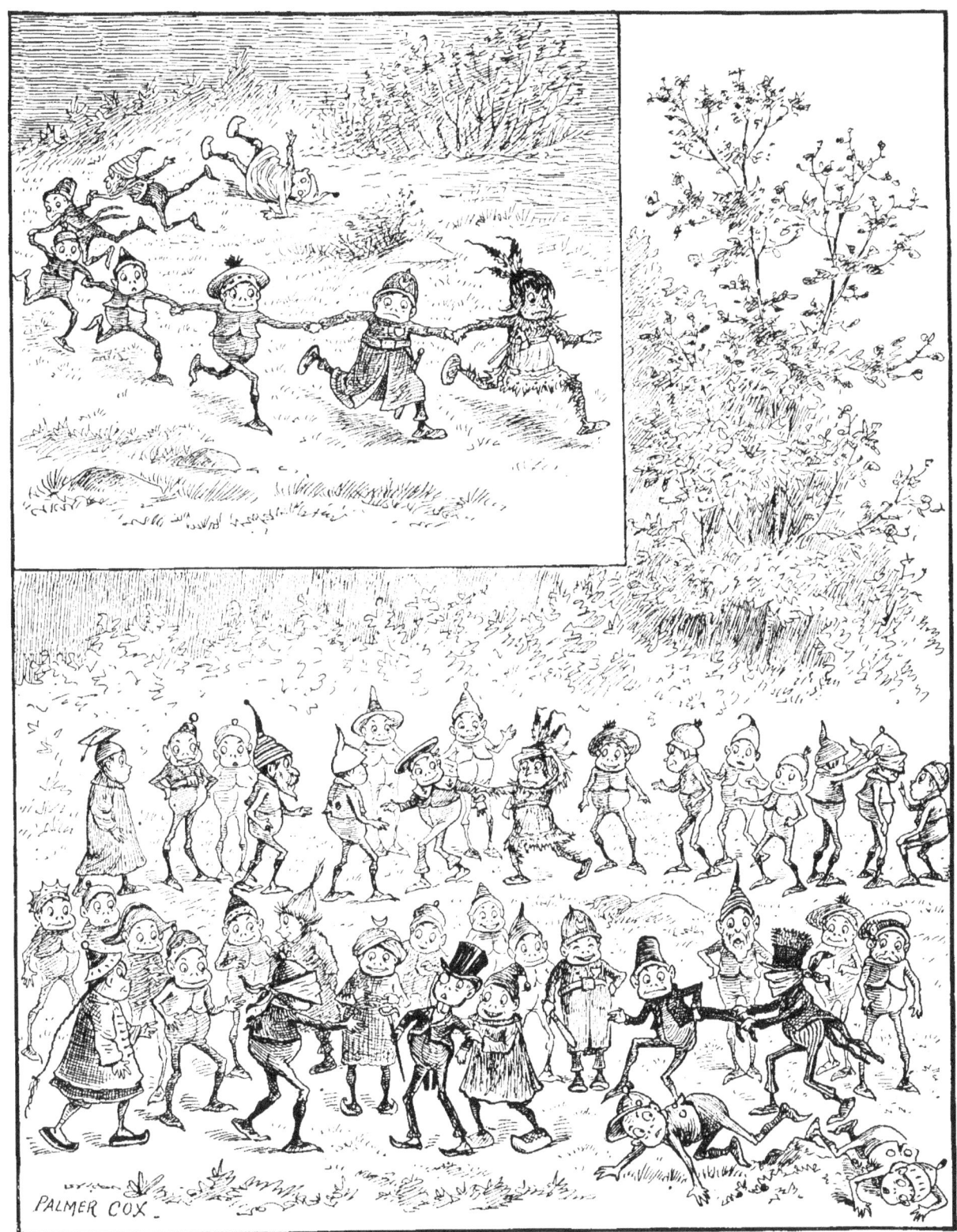

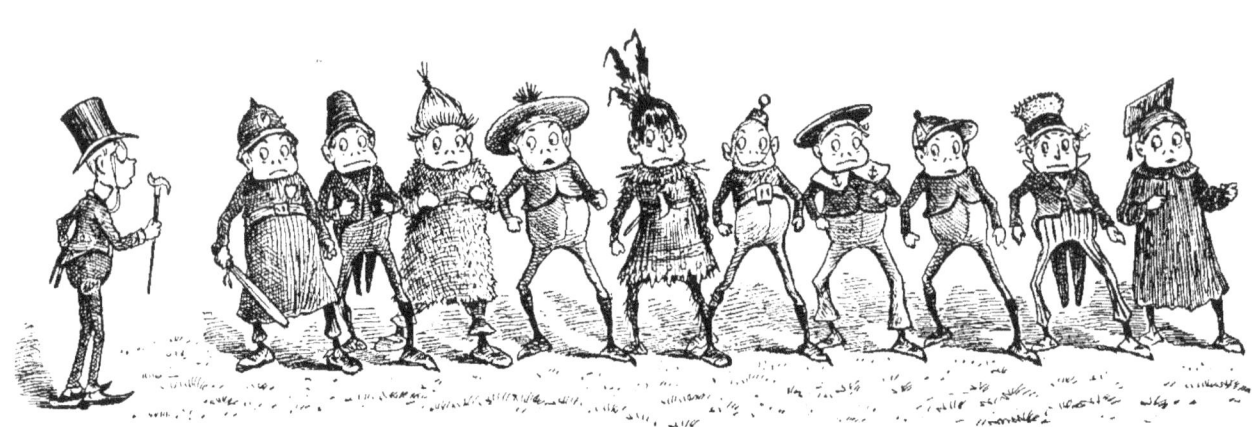

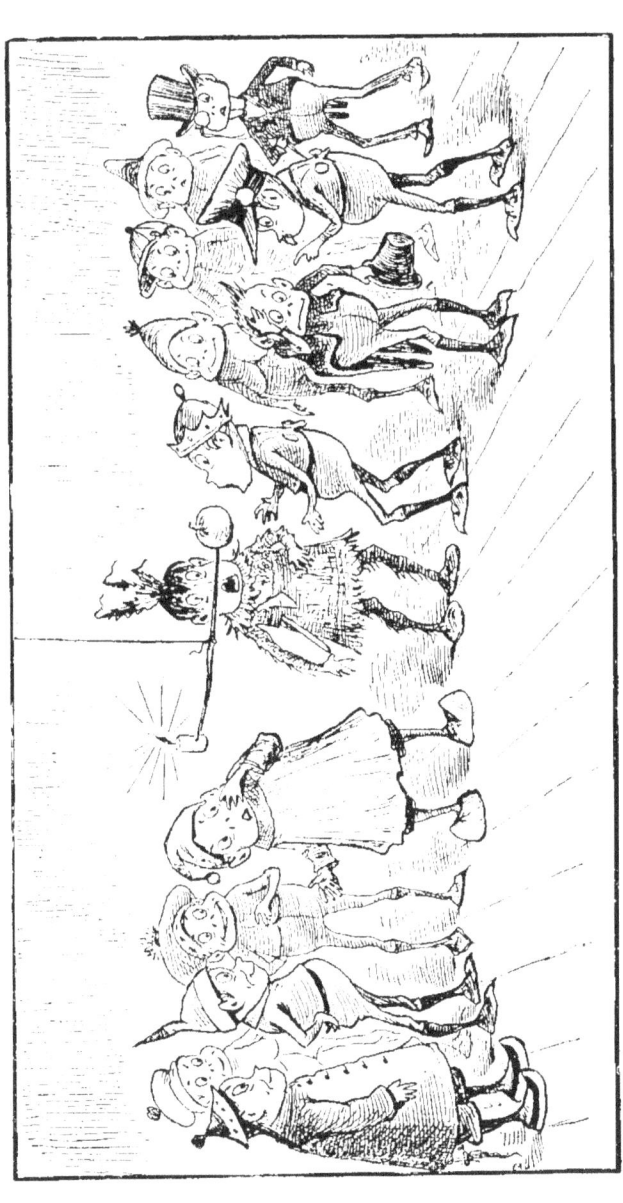
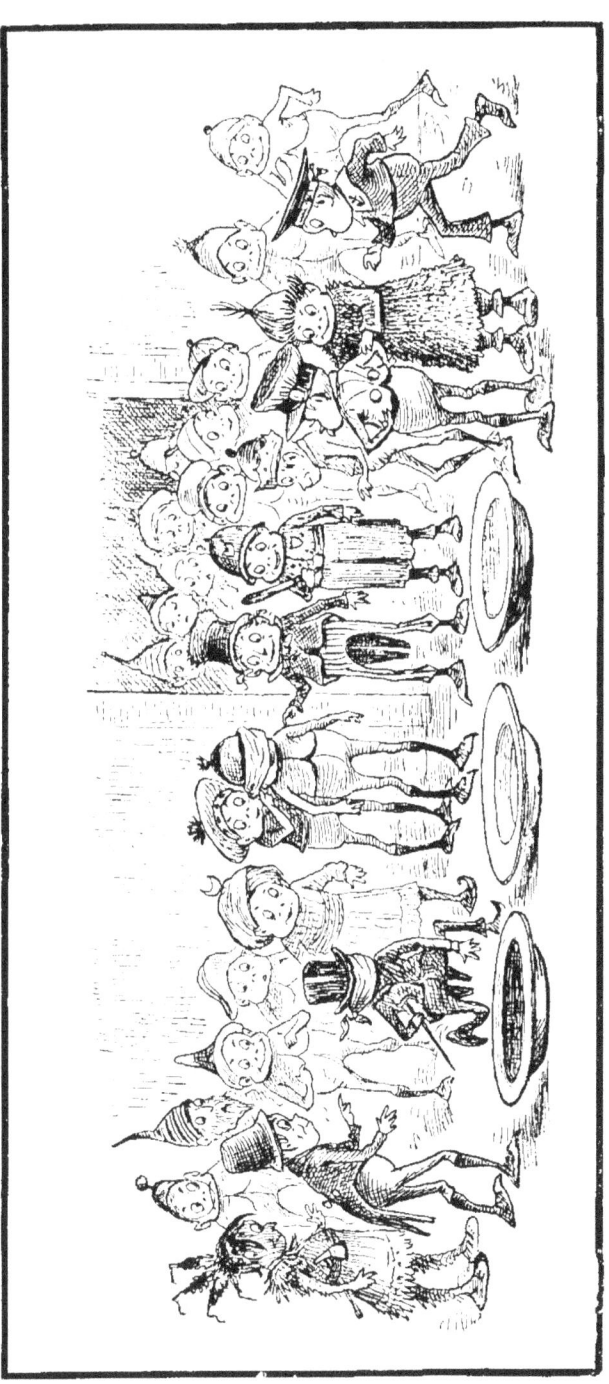

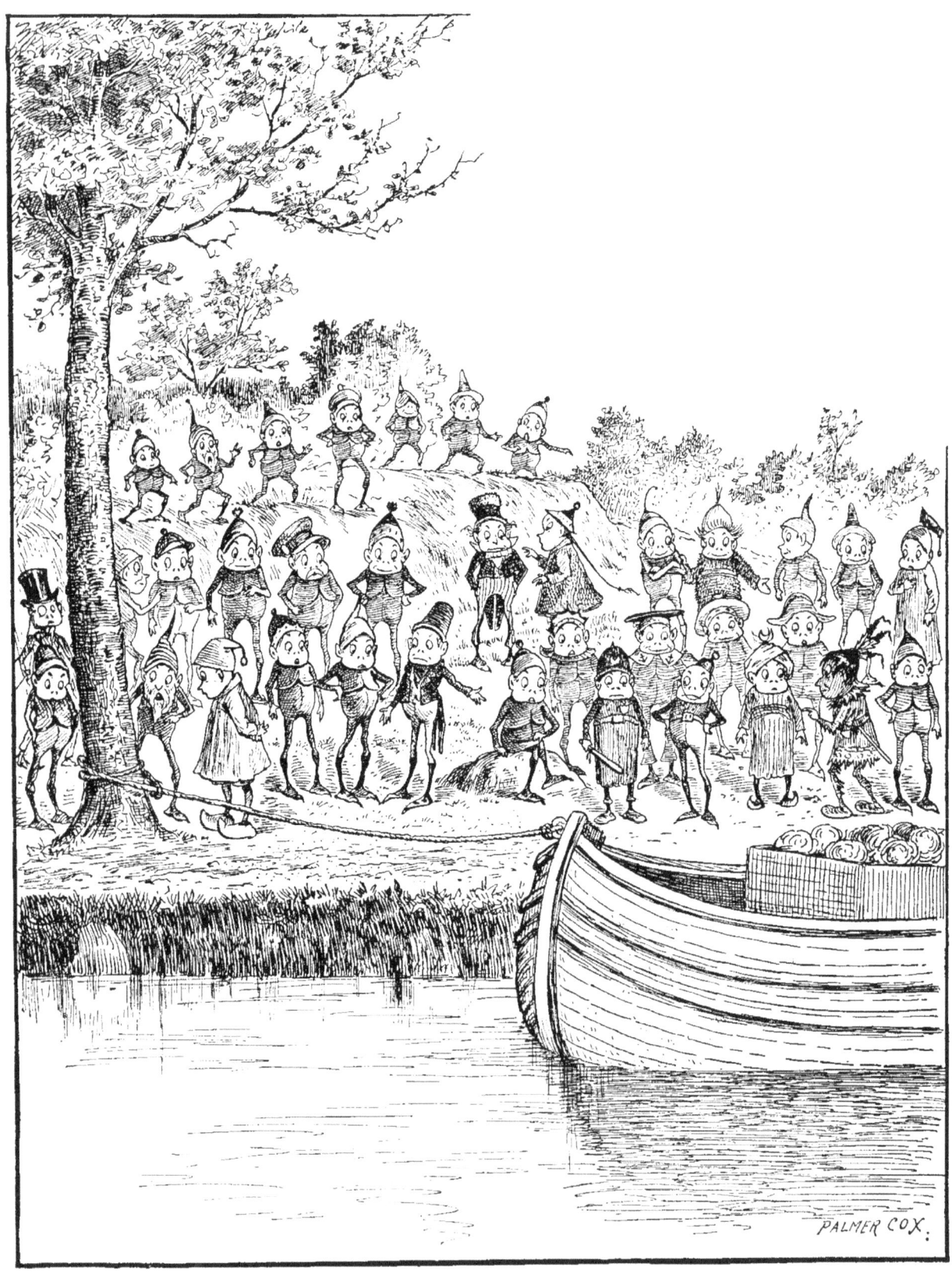

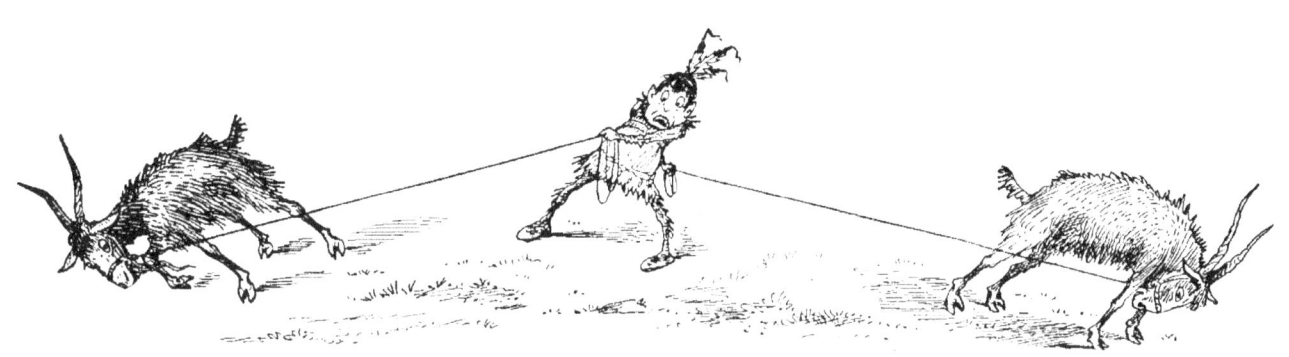
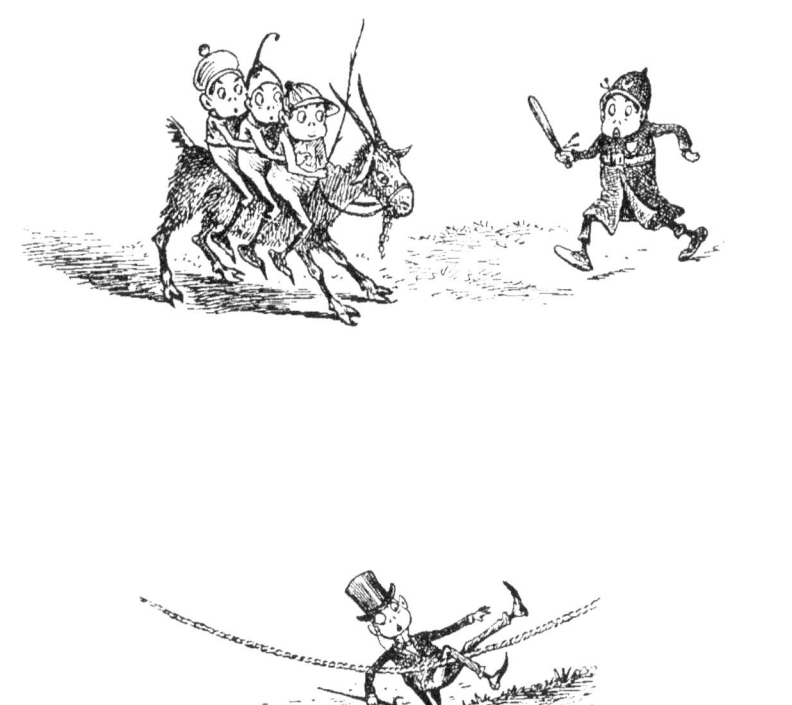
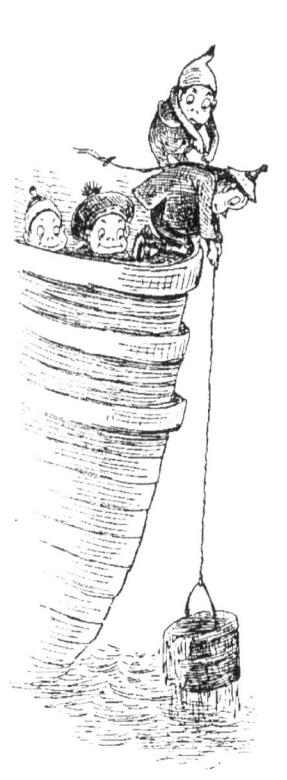

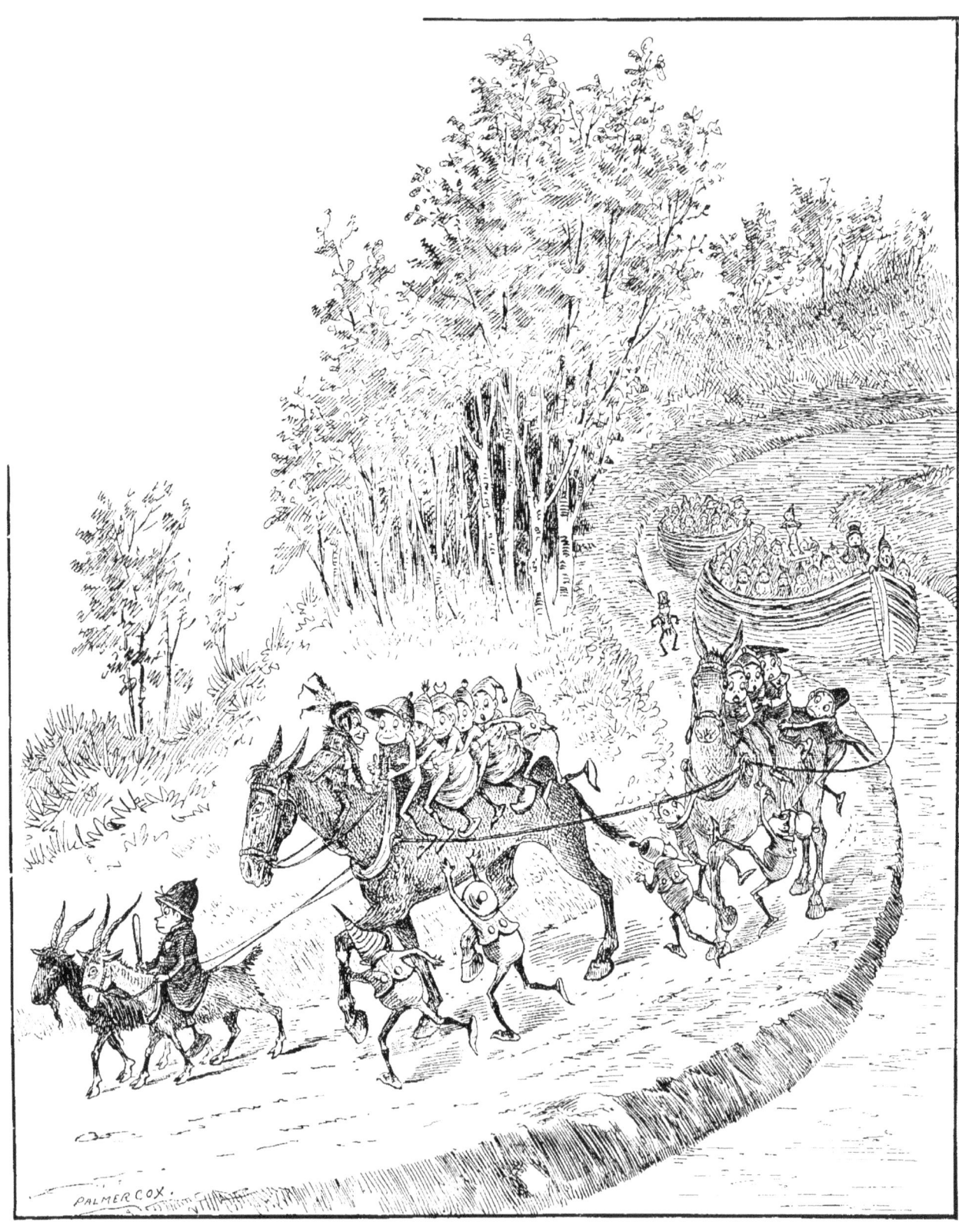

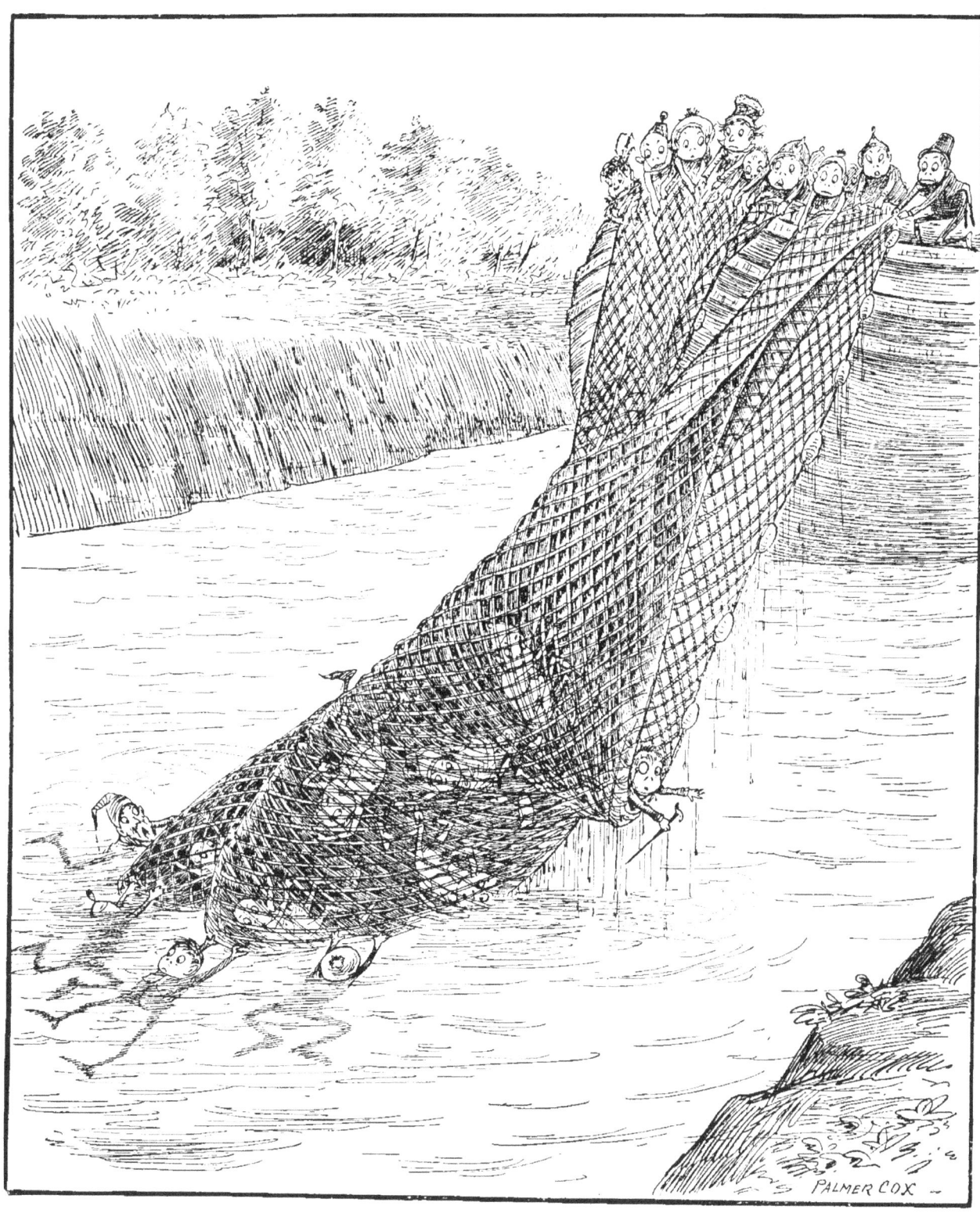

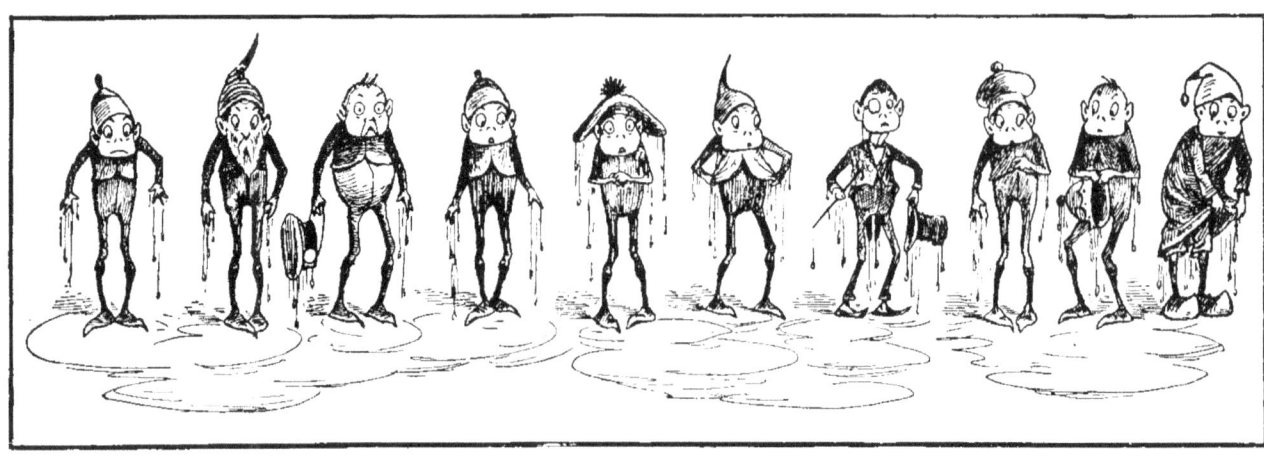

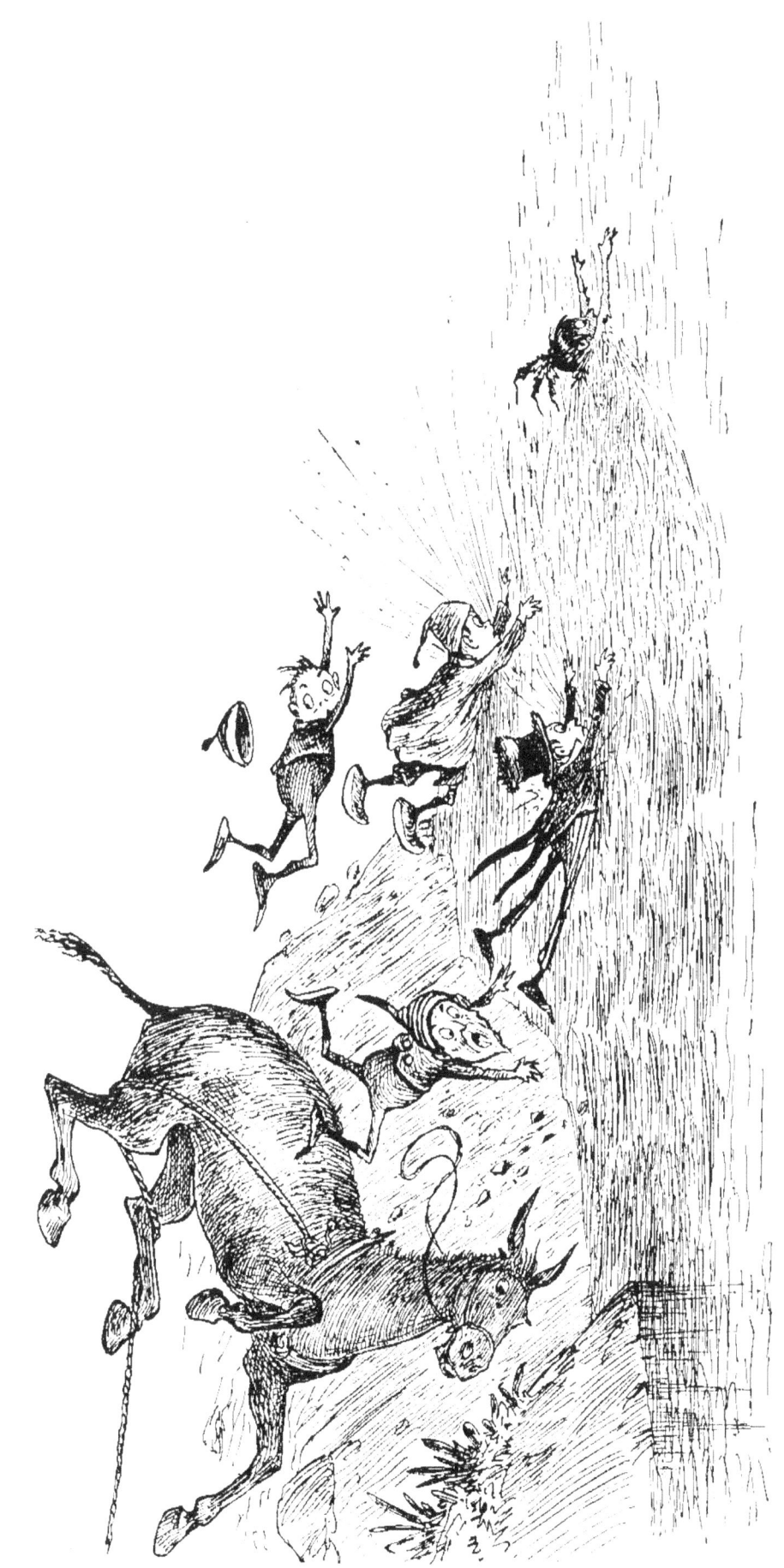

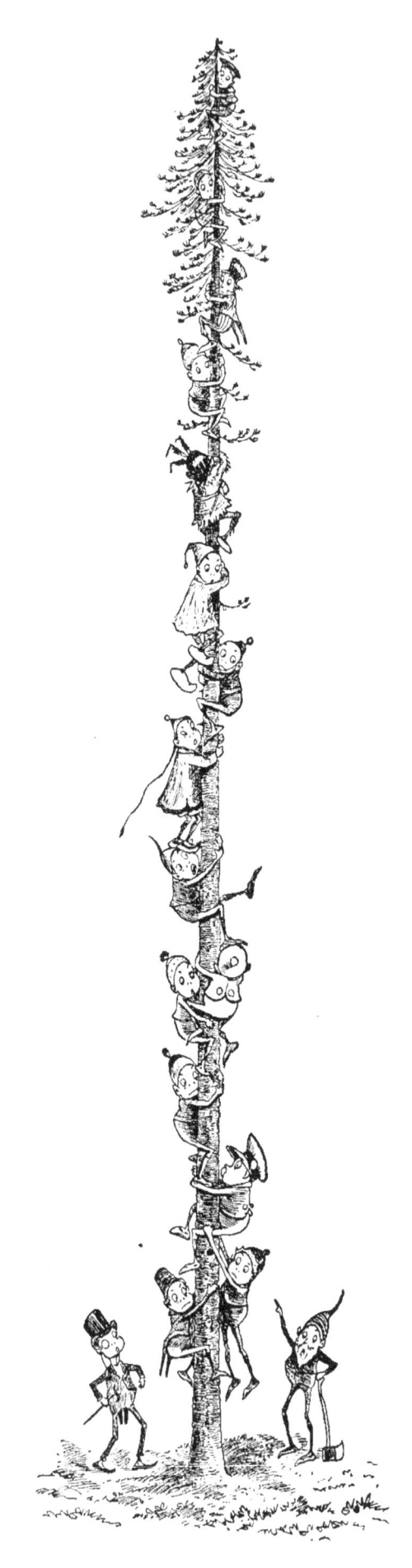

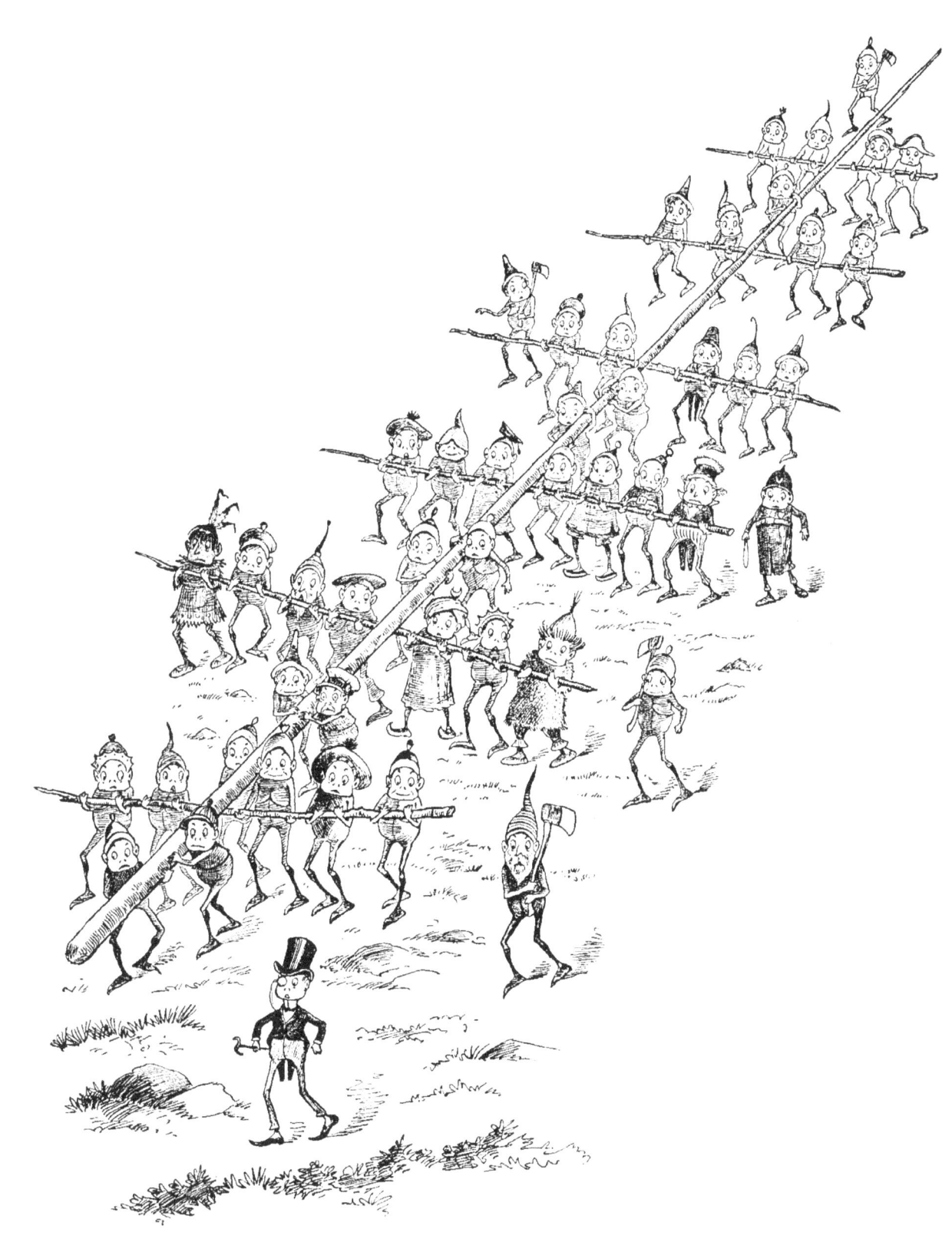

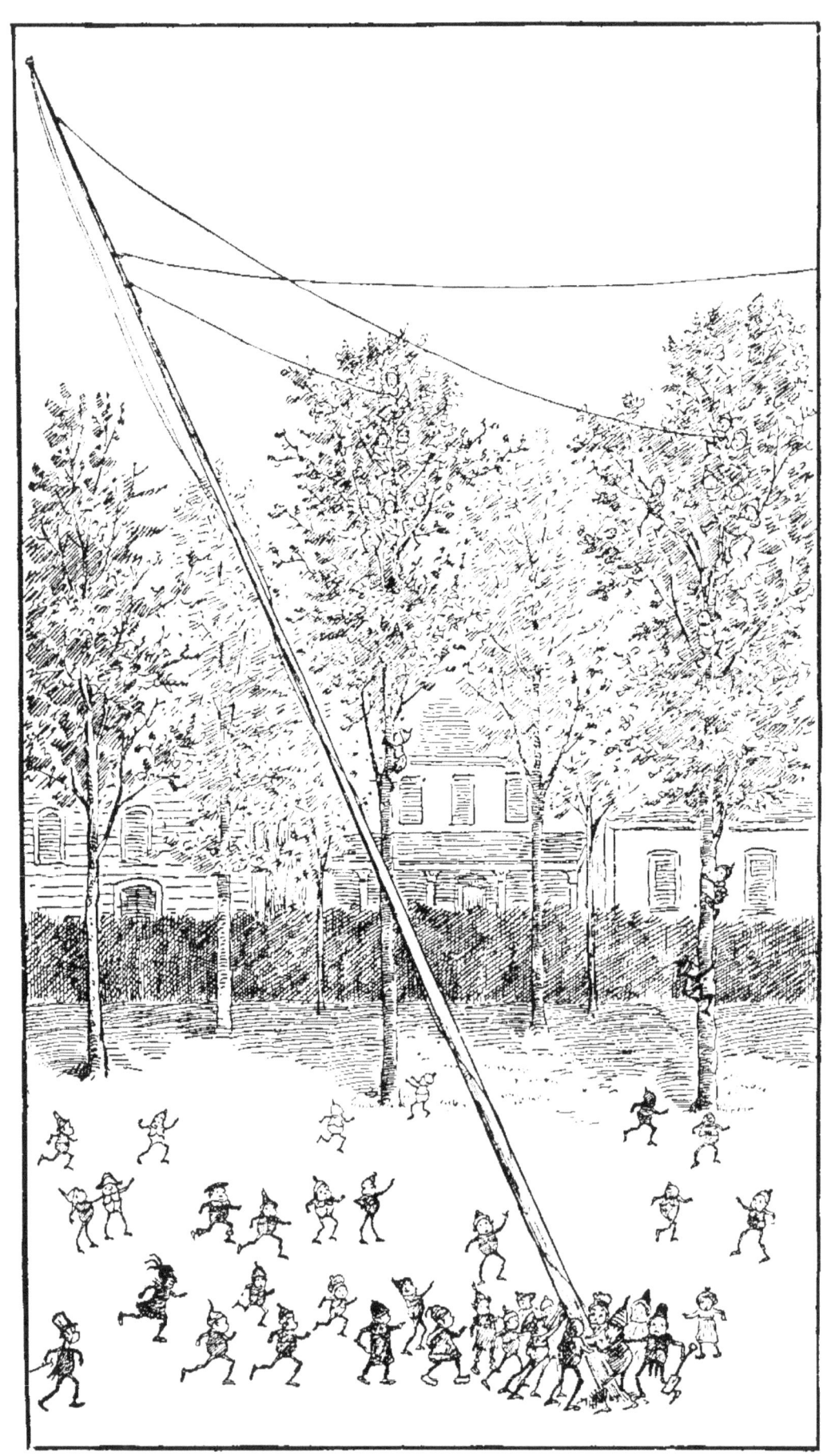

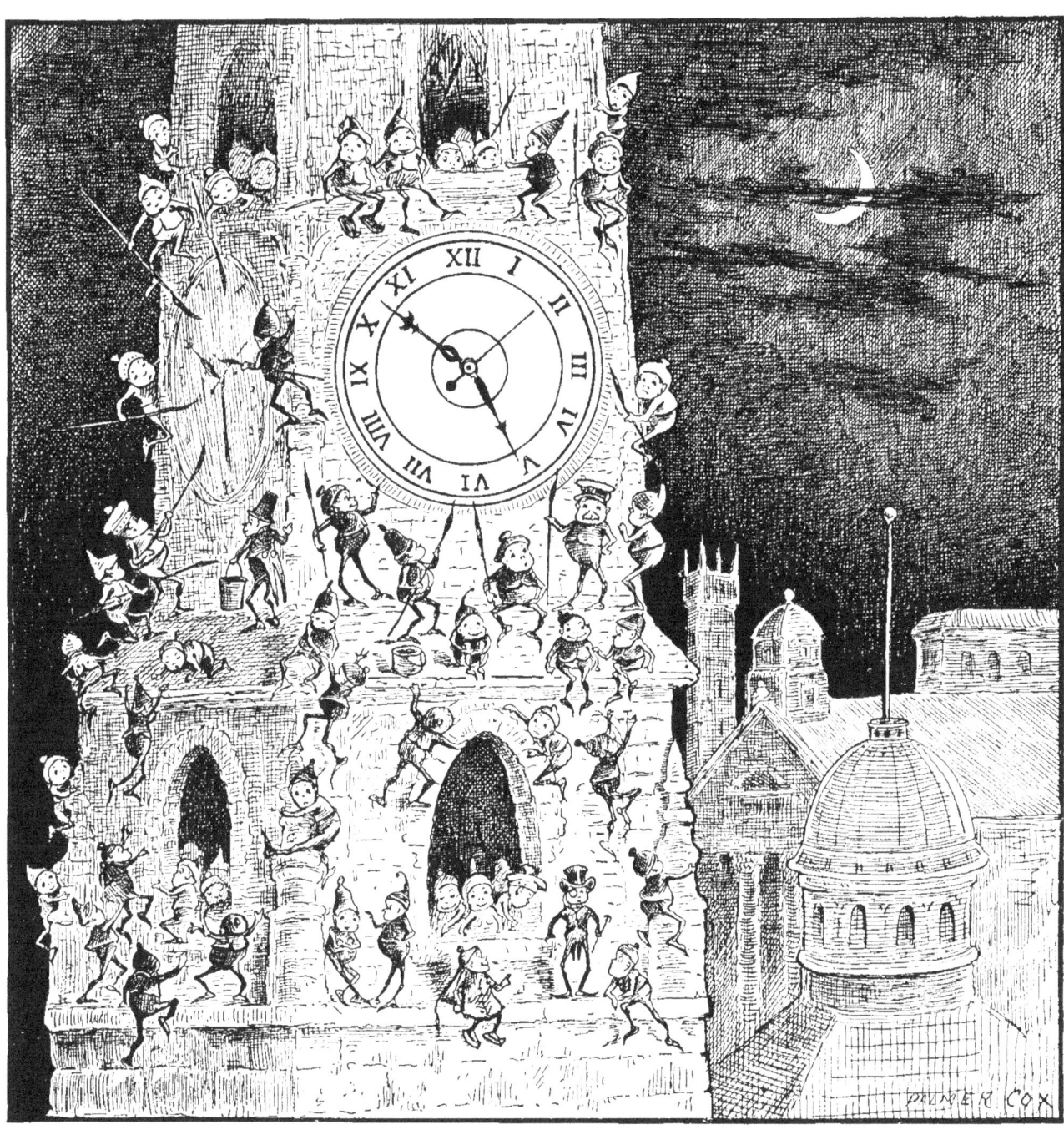

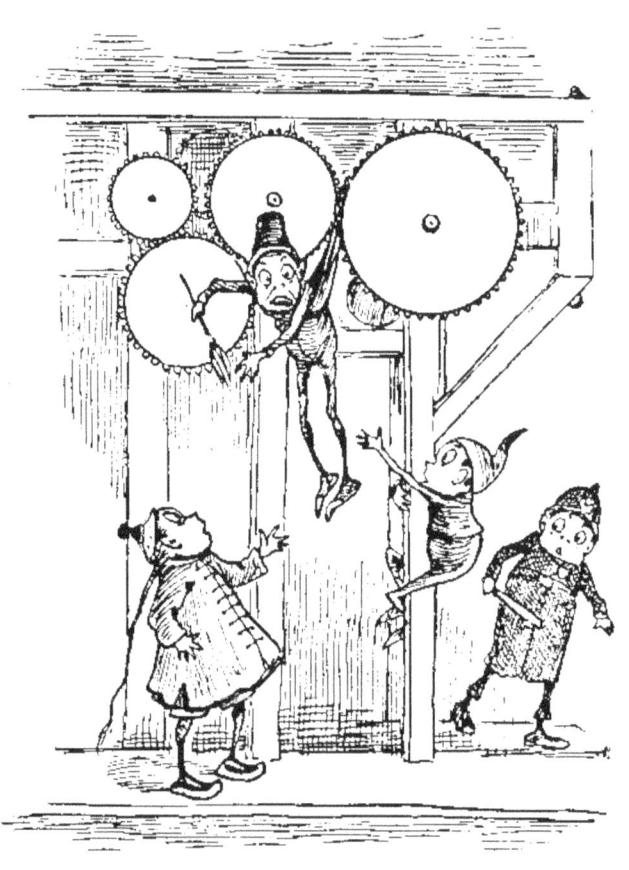

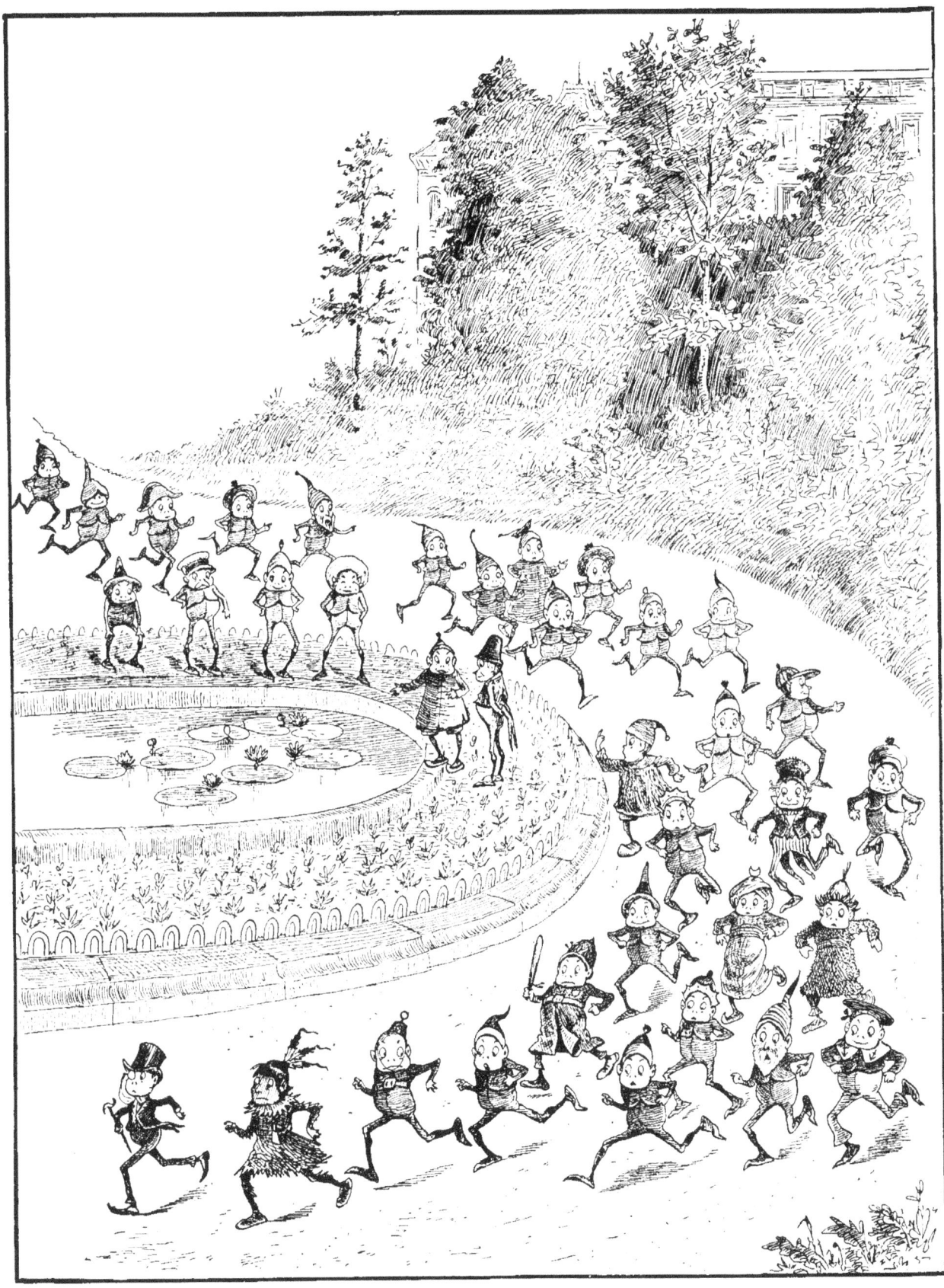

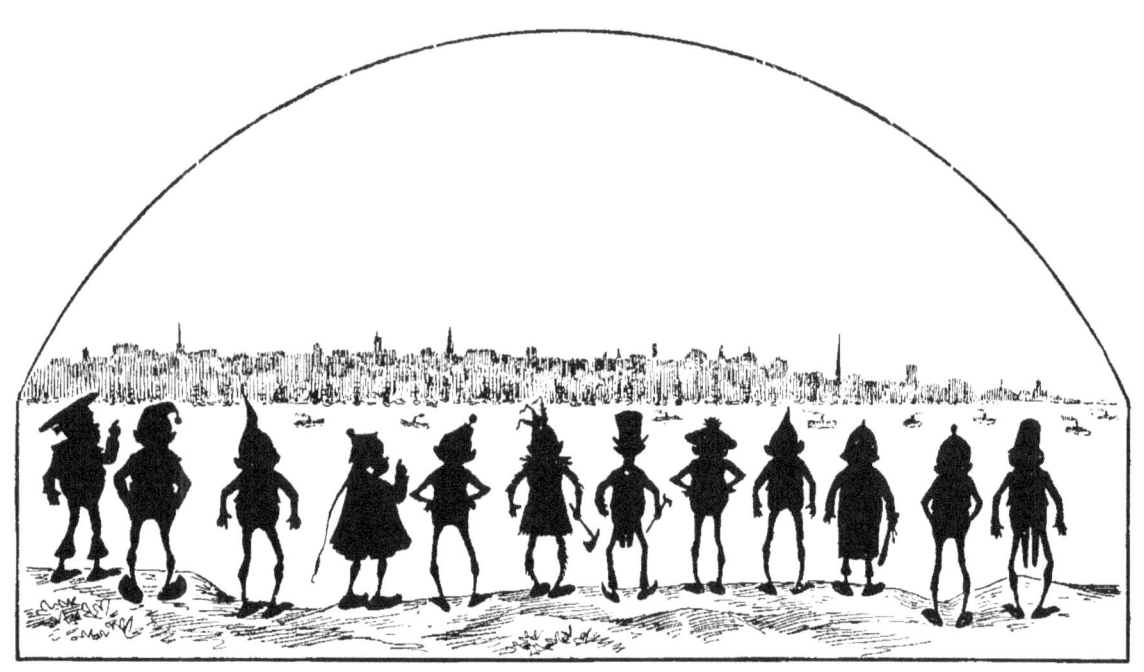

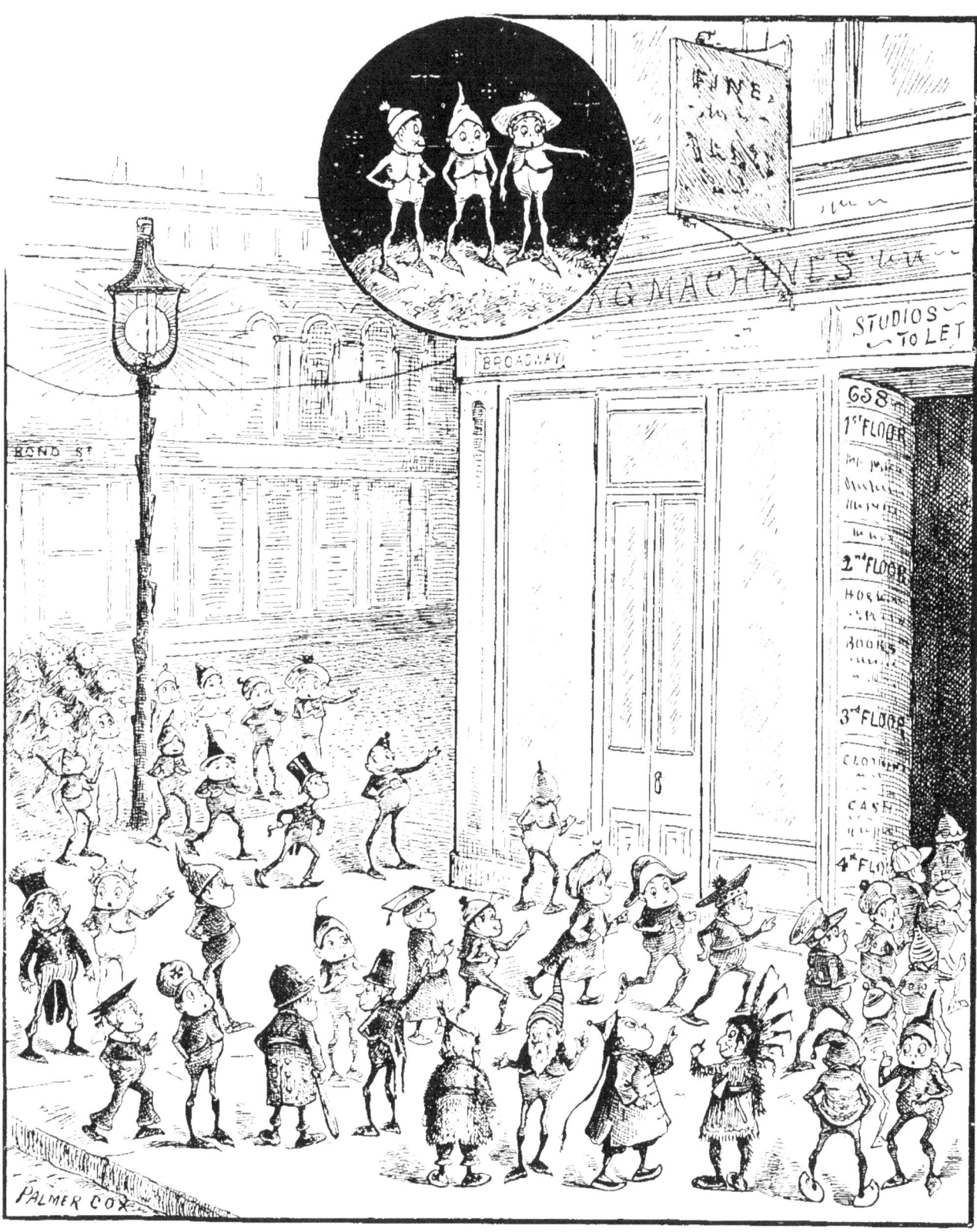

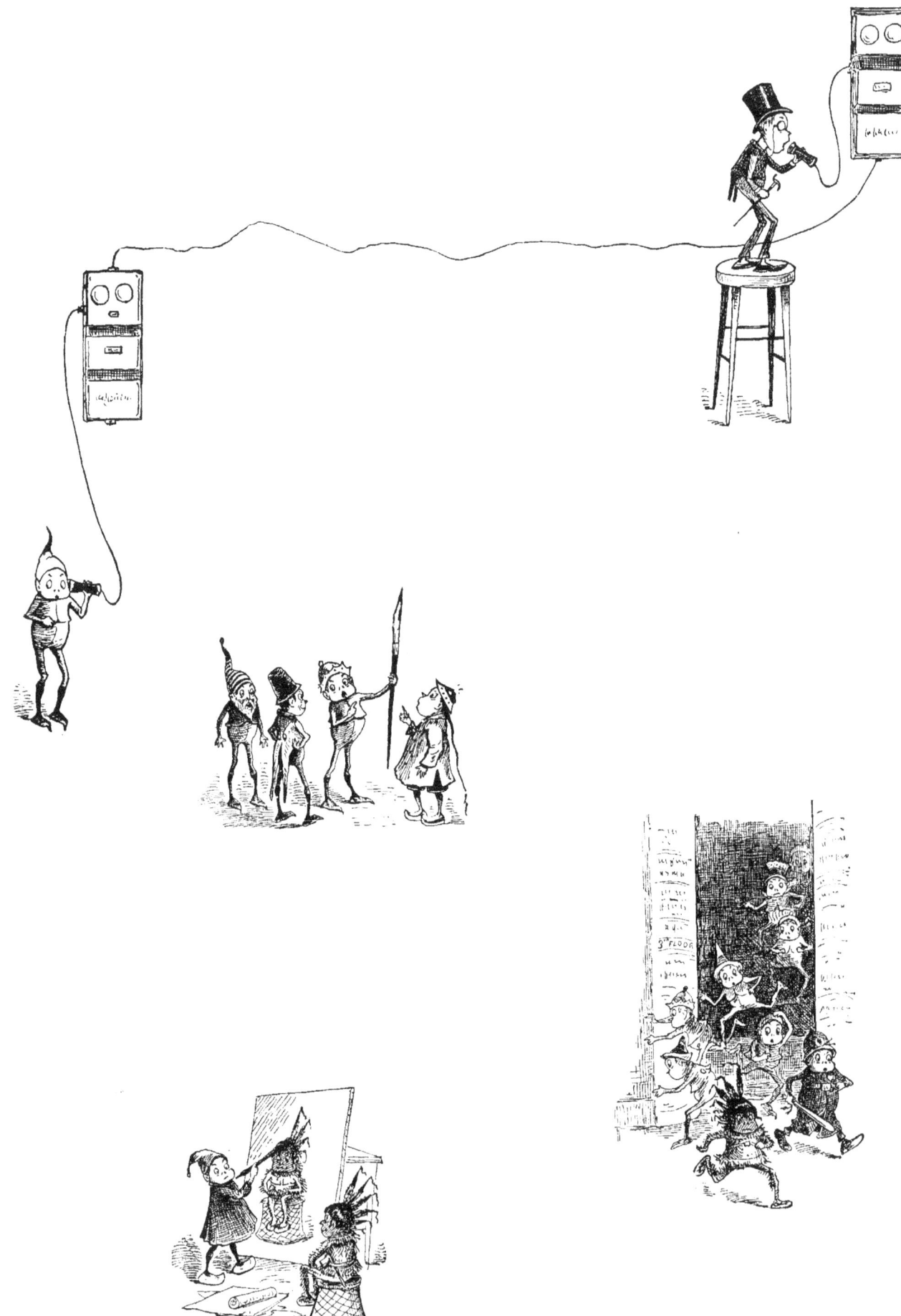

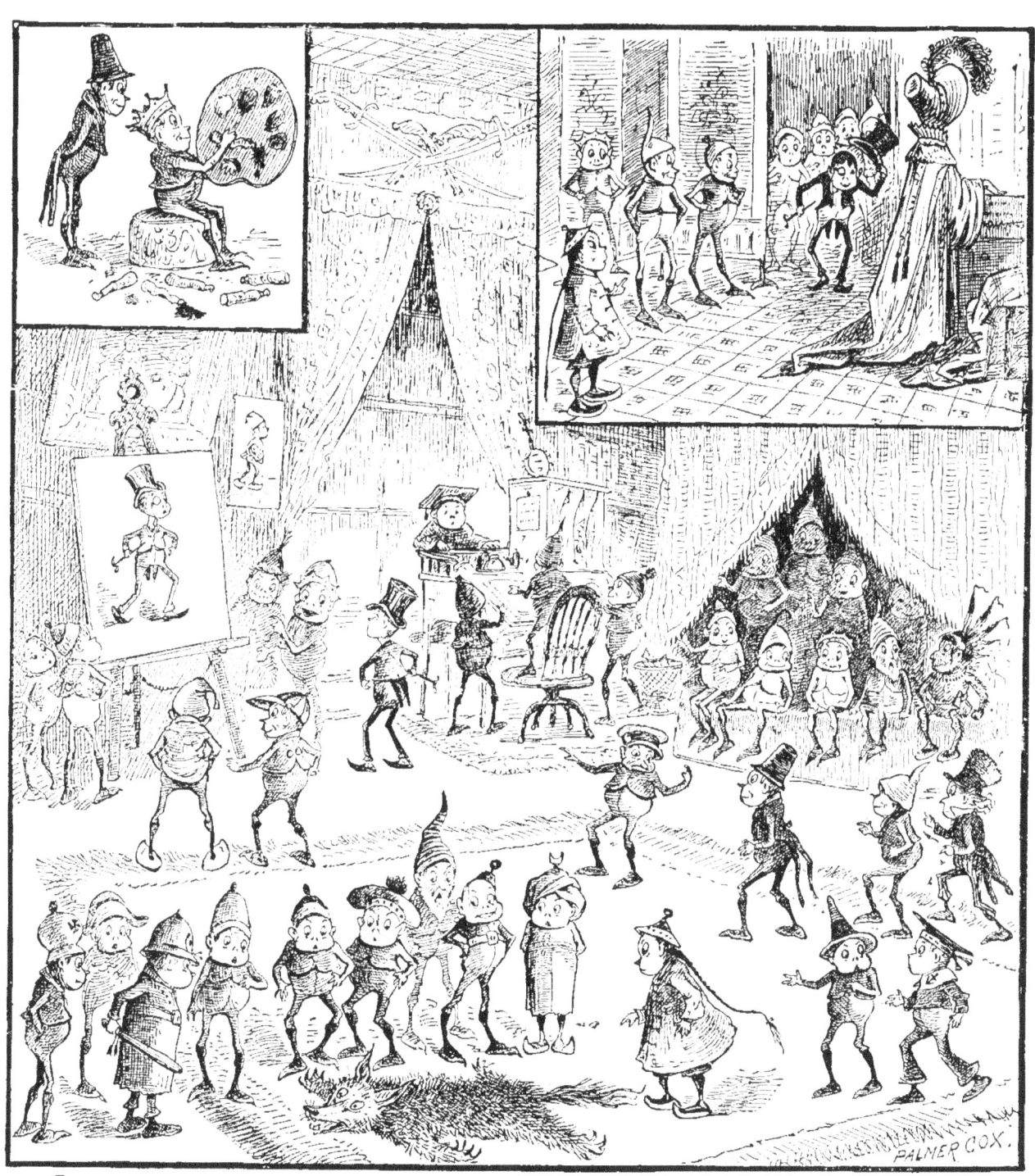

Palmer Cox Brownies ~ Trivia

Palmer Cox was born in Quebec in 1840 and was a carpenter, car builder, and railroad contractor before he became an artist.

Cox based the Brownies on names and elements of English and Scottish fairy tales told to him by his grandmother.

Brownies are imaginary sprites, similar to fairies and goblins, who delighted in doing harmless pranks and helpful deeds. They never allowed themselves to be seen by mortal eyes.

The Brownies first appeared in print in 1879 and were published in dozens of children's magazines and 16 books during the late 1800s and early 1900s.

All the Brownies are males, and were drawn to represent many different professions and nationalities.

Cox became a wealthy man thanks to the Brownies, and built a 17 room dream home he called "Brownie Castle".

The Brownie with the top hat and monocle was named Cholly Boutonniere. The patriotic Brownie was Uncle Sam.

In 1875 Cox moved to New York and many of the locations of the Brownies' adventures are based on places he visited in that region of the country, including Niagara Falls.

When Cox died in 1924, his headstone was carved with a Brownie figure and the inscription "In creating the Brownies he bestowed a priceless heritage on childhood."

The Brownies were hugely popular and appeared on games, cards, blocks, dolls, calendars, advertisements, mugs, plates, soda pop, a slot machine, and even were the inspiration for Kodak's "Brownie Camera" ... yet Cox never received any money for the commercial use of his work.

www.ingramcontent.com/pod-product-compliance
Lightning Source LLC
Chambersburg PA
CBHW080620190526
45169CB00009B/3247